Images of Modern America

NORTHLAND MALL

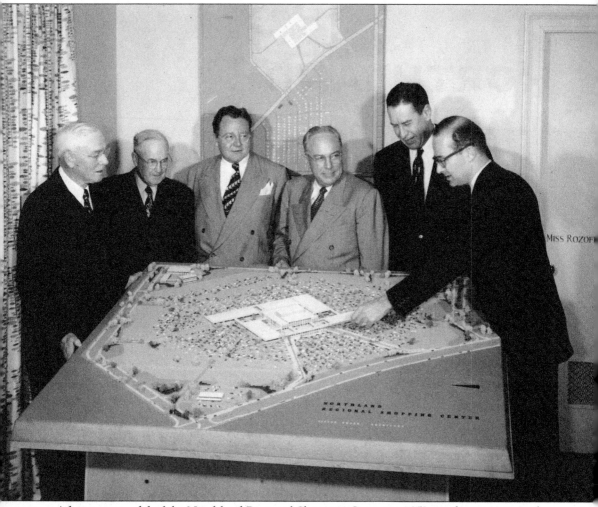

MISS ROZOF

Admiring a model of the Northland Regional Shopping Center in 1952 are the executives who ran the J.L. Hudson Co. and held almost identical positions with Northland. They are, from left to right, Richard Webber, chairman of the board; Oscar Webber, president; James B. Webber Jr., vice president and general manager; Foster Winter, treasurer; unidentified; and Karl Van Leuvan of Gruen Associates, the architects. Not pictured are James B. Webber Sr. and Joseph L. Webber, both vice presidents. (Courtesy of Foster Winter and Michael Hauser.)

ON THE FRONT COVER: *The Boy and Bear*, by Marshall M. Fredericks, on the Terrace. (Courtesy of Mike Grobbel and "Bulletmagnet" at DetroitYes.com.)

UPPER BACK COVER: Postcard aerial view of Northland Center looking northwest from Eight Mile and Greenfield Roads. (Photograph by Larry Witt, courtesy of Jeff Wasilewski.)

LOWER BACK COVER: (from left to right) Historic directional sign designed by Alvin Lustig and marquee (courtesy of Gruen Associates), the Circus in parking lot G, August 1972 (courtesy of Southfield Library; see page 24), grand opening of Northland Playhouse geodesic dome, later the Mummp (courtesy of Ray White; see page 94.)

Images of Modern America

NORTHLAND MALL

GERALD E. NAFTALY

FOREWORD BY JAMES B. WEBBER III

ARCADIA
PUBLISHING

Published by Arcadia Publishing
Charleston, South Carolina

Library of Congress Control Number: 2015957268

For all general information, please contact Arcadia Publishing:
Telephone 843-853-2070
Fax 843-853-0044
E-mail sales@arcadiapublishing.com
For customer service and orders:
Toll-Free 1-888-313-2665

Visit us on the Internet at www.arcadiapublishing.com

To my parents, Grace and Bill Naftaly, of blessed memory, with love and thanks for exposing the values and total experience of Northland's activities, shopping, and sculptures that have stayed with me for a lifetime.

CONTENTS

FOREWORD

With great pride and admiration, I appreciate viewing this collection of images and memories of Hudson's and Northland Mall. I commend Jerry Naftaly, the former mayor of Oak Park, for undertaking this endeavor. I'm honored to write this foreword as the great-great-nephew of the late Joseph Lowthian (J.L.) Hudson, founder of Hudson's.

In Images of Modern America: *Northland Mall*, Jerry Naftaly has accumulated and captured what Northland was all about. Northland was Hudson's, the flagship name; the variety of stores filling every need; the sculptures, art, and courtyards; and countless activities for people of all ages. While the Detroit store was our flagship, holding many great memories, Hudson's expanded into the suburbs starting in 1954 with Northland. The company continued to emphasize customer service and high quality merchandise. Northland Center was the largest shopping center at the time and became a model for others. This collection helps to show Northland, as Jerry so capably points out, as the complete family experience that it was. I compliment Jerry Naftaly and Arcadia Publishing.

I have many cherished memories of Hudson's and Northland. J.L. Hudson's nephews, including my grandfather James Webber Sr. and his brothers Oscar, Richard, and Joseph were all officers of the J.L. Hudson Company and continued to run the company following the passing of J.L. Hudson. My father, James Webber Jr., also served as an officer and was the one who urged the family to expand into the suburbs. One of my favorite memories is attending the grand opening of Northland on March 12, 1954, opening the doors to the public by turning the lock with the same key that was used to open Hudson's first Campus Martius store in 1881. Jerry has included the photograph autographed by Dwight D. Eisenhower.

I hope you enjoy the history and memories.

—James B. Webber III

ACKNOWLEDGMENTS

This book would not be possible without contributions from many people. My thanks go to everyone for helping bring this book to fruition. Without your courtesy, time, and efforts, I would not have been able to include all these memories. Thank-yous are extended to the following people: Harold and Iris Mickel for your time and help; Michael Hauser, local Hudson's expert, for sharing your valuable collection; Matthew Parrent and Michael Enomoto of Gruen Associates for providing dozens of high-quality images; Jerry Webber for the foreword and for sharing your collection; Joe Hudson Jr. and Jennifer Hudson Parke for your time, photographs, and historical perspectives; attorney John Polderman and mall manager Miles McFee for allowing access to Northland's grounds and archives; Carl Fredericks for your stories and memories of your talented father, Marshall Fredericks; Dennis King for the archives from the American Institute of Architects –Michigan; Janet Levine for the media kit; Detroit Historical Society's Adam Lovell, Eric Dalton, and Tracy Irwin; Elizabeth Murray Clemens; and Jim Luxton, Aaron Tobin, and Harold Mickel for your teamwork.

My appreciation goes to the great people of the great city of Southfield, including Mayor Ken Siver; former mayor and city councilman Don Fracassi; city administrator Fred Zorn; chief of police Eric Hawkins; attorney Sue Ward-Witkowski; Southfield police officers Kelly Buckberry, Devlin Williams, Kelly Pate, and Walter Menzel; sign inspector Ed Gardella and Connie Mays for all the valuable images; the Southfield Library; city librarian Dave Ewick; Southfield Historical Society president Darla Van Hoey and her group; Tom Frey for access to the historical collection his father, Dick Frey, donated to the library; Professor Alex Wall; and Dr. Richard Longstreth. Thank you, Mike Grobbel, for the cover image; Bruce Kopytek for the research; Marcie Lebow, Jeff Wasilewski, Linda Solomon, Todd and Lee Weinstein, Bruce Arnett, and Gary Cocozzoli of Lawrence Tech; Elizabeth Murray Clemens; Karla Bellafant; Iain MacGregor; Jon Kuiper; Eugene Lumberg, Eugene Grew; Daniel Redstone; Andrea Rogoff; Mel Newman; Allan Gelfond; my niece, award-winning children's author Susan B. Katz, for her inspiration—and many more.

Thanks go to those who shared photographs or memories. Those reprinted herein have also been acknowledged. Space limitations keep me from naming many more terrific people, but I am grateful to all of you. Thank you, Arcadia Publishing, and my contacts, Caitrin Cunningham and Jeff Ruetsche, for your assistance and advocacy.

Some images in this volume appear courtesy of Southfield Public Library (SPL), City of Southfield (COS), Northland Archives (NA), and Michael Hauser (MH). Unless otherwise noted, the rest of the images are part of the author's collection.

INTRODUCTION

On May 7, 1952, ground was broken for Northland Center. On March 12, 1954, the ribbon was cut and the key was turned to open the door. Officially, the center opened to the public on March 22, 1954; the story, however, began several years earlier. Northland was the vision of architect Victor Gruen, who believed that a shopping center was more than a collection of stores. In a June 1952 interview with Dr. Richard Longstreth, which Prof. Alex Wall more fully describes in his book *Victor Gruen: From Urban Shop to New City*, Gruen expresses his belief that a large suburban shopping center should resemble a city, with "post office, doctor's offices, rooms for club activities, where shopping would become pleasure rather than a chore and larger centers could be built similarly with automobile traffic diverted around . . . or . . . under them."

Gruen also believed that "the shopping center of tomorrow will, besides performing its commercial function, fill the vacuum created by the absence of social, cultural and civic crystallization points in our vast suburban areas." Gruen and economist Larry Smith, a member of his team, said that to fulfill this function was "to go beyond the commercial needs, take advantage of public areas and realize an architectural concept." Two years prior to the opening of Northland, Gruen gave a lecture before the Detroit chapter of the American Institute of Architects and noted the 10 requisites for a successful shopping center. He said that "it must be in the right city, in the right area, on the right spot and of the right size. It must be easily accessible, offer complete services, and the highest degree of obtainable shopping convenience. It must lease to the right tenants on the right terms. It must offer the most attractive shopping surroundings attainable."

In 1949, Gruen presented his plans to Oscar Webber, then president of Hudson's, for the department store to build its own regional shopping centers in four locations—Northland, Eastland, Westland, and Southland. In order to serve the larger region, the company needed to expand into the suburbs. Gruen built a team, including Karl Van Leuven and economist Larry Smith.

Gruen scouted locations, noting demographics and population trends, and found one such area (see page 10). Northland was not intended to be the first shopping center. Located near prosperous Grosse Pointe, Eastland was designated as the first. However, the Korean War broke out and necessary building materials were unavailable. Gruen had set up a team with the architect in the central role, along with consultants, economists, and bankers working with the client. Gruen designed the centers to include offices, medical buildings, hospitals, schools, and apartments to create a "multifunctional regional center." In 1951, Hudson's announced revised plans that would open Northland first. A consultant hired by the Webber family believed that the Northland Center project would work. Gruen's own economist was not as sure, based on shopping trends and analysis. Disagreement within the Webber family caused some dissension. James Webber Jr. convinced his uncles that in order to compete with other large chains, they would need to expand to the suburbs. James Webber Sr. believed they should focus on the downtown Detroit store. Plans would go forward and when institutional investors balked, Oscar Webber decided to finance the endeavor himself. Northland was built at a cost of $25 million. The shopping center received more than 300 applications for the initial 80 tenant spaces.

The land was in Southfield Township. Members of the Clinton family owned the farms. Legend has it that the family requested their children be bussed to Southfield schools, but Southfield refused. The new Oak Park School District, just across Greenfield Road, was approached and agreed to provide bussing. No paper record of any vote could be found to substantiate annexation by Oak Park School District over Southfield schools, but (maybe by a handshake) this property is taxable by Oak Park. Southfield Township, after a number of unsuccessful annexation attempts by the City of Oak Park and others, was approved by voters in April 1958 as the charter City of Southfield. A little-known fact is that the new city had no funds to operate from April 28, 1958, to July 1, 1958, and turned to Richard W. "Dick" Frey, who helped finance the city's payroll and expenses. Frey served as Northland's construction coordinator and, eventually, president of Dayton-Hudson's Shopping Center Inc.

One

THE HISTORY

Joseph Lowthian Hudson (October 17, 1847–July 5, 1912) was born in England and immigrated with his family first to Ontario and then to Michigan. In 1881, Hudson opened a small men's and boy's store, the J.L. Hudson Company, in Detroit. Before his death in 1912, it grew to be the city's largest department store. Although he never married, Joseph L. Hudson was the head of his family. The four sons of his sister, Mary, married to Joseph T. Webber of Ionia, Michigan, were his particular protégés. Upon Joseph's death, the Webber brothers inherited the majority of the company's stock and also the company's destiny. (Courtesy of Hudson-Webber Foundation.)

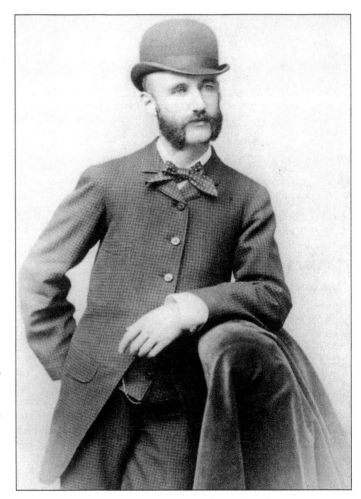

Victor Gruen was born Viktor Gruenbaum in Vienna on July 18, 1903, to a prominent Hamburg Jewish family. Enrolled at Vienna's Master School for Architecture, he resigned after two semesters to care for his mother and sister. He married in 1930, came to America in 1938, and in 1940 formed Gruenbaum and Krummek, Designers, in New York. Moving to Los Angeles in 1944, he became an American citizen, changing his name to Gruen. He formed Victor Gruen Associates in 1951 prior to working with Hudson's. (Courtesy of Library of Congress.)

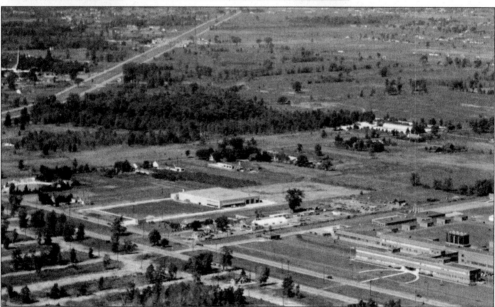

Lawrence Tech wanted to purchase the war surplus Vickers Plant's 81 acres on Eight Mile Road in Oak Park (at right), but the State of Michigan acquired it for the Detroit Artillery Armory. Lawrence Tech then sought the 92-acre area with the trees at left center, known as the "Clinton estate farm" in Southfield Township. In 1947, Lawrence Tech bought this for $250,000 for a new campus, depleting its building fund. In 1950, the trustees sold the property for $600,000. Hudson's really wanted it. (Photograph by James Shepperd, author's collection.)

Oscar Webber (center), president of the J.L. Hudson Co., turns over the first shovel of dirt on May 7, 1952, officially breaking ground for the ambitious new Hudson's branch and Northland Center. With him are chairman Richard Webber (left) and general manager James B. Webber Jr. The new development was expected to serve an area of 500,000 people with parking for 7,500 and the potential for 10,000. (Courtesy of Foster Winter, MH.)

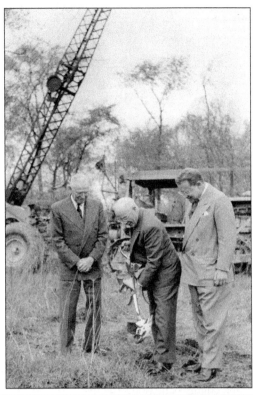

The official grand opening of the Northland Shopping Center culminated in the ribbon cutting and key ceremony on March 12, 1954, led by five-year-old Jerry Webber, great-great-nephew of J.L. Hudson. With him are his uncles and father, who led the nearly four-year effort of planning and constructing the $25 million, 180-acre site. Newspapers, magazines, television, and radio from across the nation and beyond attended the press opening of the "World's Largest Shopping Center." Northland opened to the public on March 22, 1954. (MH.)

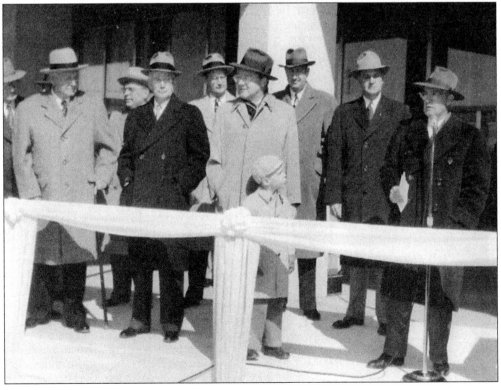

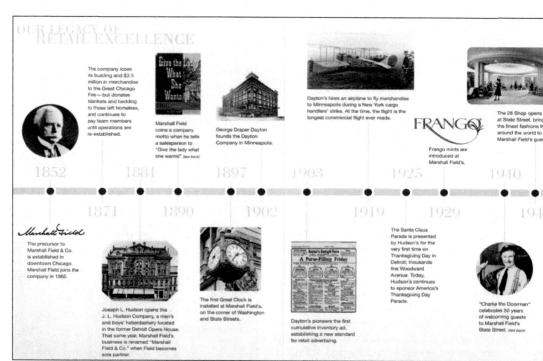

The company loses its building and $3.5 million in merchandise to the Great Chicago Fire—but donates blankets and bedding to those left homeless, and continues to pay team members until operations are re-established.

1852

Marshall Field coins a company motto when he tells a salesperson to "Give the lady what she wants!" *(see back)*

1881

George Draper Dayton founds the Dayton Company in Minneapolis.

1897

Dayton's hires an airplane to fly merchandise to Minneapolis during a New York cargo handlers' strike. At the time, the flight is the longest commercial flight ever made.

1903

FRANGO

Frango mints are introduced at Marshall Field's.

1925

The 28 Shop opens at State Street, bringing the finest fashions from around the world to Marshall Field's guests.

1940

Marshall Field

The precursor to Marshall Field & Co. is established in downtown Chicago. Marshall Field joins the company in 1865.

1871

Joseph L. Hudson opens the J. L. Hudson Company, a men's and boys' haberdashery located in the former Detroit Opera House. That same year, Marshall Field's business is renamed "Marshall Field & Co." when Field becomes sole partner.

1890

The first Great Clock is installed at Marshall Field's, on the corner of Washington and State Streets.

1902

Dayton's pioneers the first cumulative inventory ad, establishing a new standard for retail advertising.

1919

The Santa Claus Parade is presented by Hudson's for the very first time on Thanksgiving Day in Detroit; thousands line Woodward Avenue. Today, Hudson's continues to sponsor America's Thanksgiving Day Parade.

1929

"Charlie the Doorman" celebrates 50 years of welcoming guests to Marshall Field's State Street. *(see back)*

1941

This time line details milestones in the corporate history of Marshall Field & Company (1852), J.L. Hudson Company (1881), and the Dayton Company (1902). It includes various mergers and name changes and notes the first Thanksgiving Day parade in Detroit, sponsored by Hudson's. Notable are the opening of Northland in 1954, the 1969 merger of the J.L. Hudson Co. with Dayton Co. creating Dayton-Hudson, the acquisition of Marshall Field & Co. in 1990, and subsequent

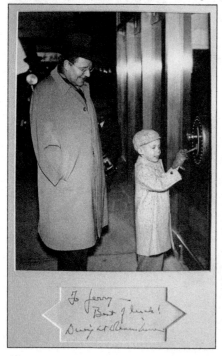

James B. "Jerry" Webber III, with the key and lock originally used to open J.L. Hudson's first store in Detroit in 1881, unlocks the door to Northland's Hudson's. Watching his son is James B. Webber Jr., nephew of J.L. Hudson and Hudson's vice president. The key passed from William Petzold, vice president and one of Hudson's first three employees who served for 70 years, to Richard Webber, chairman, who handed it to James Webber Jr., who passed it to his son. Pres. Dwight D. Eisenhower, visiting Detroit, signed the photograph for young Jerry. (Courtesy of Jerry Webber.)

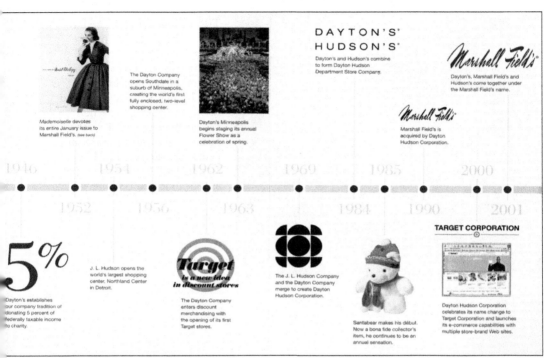

The Dayton Company opens Southdale in a suburb of Minneapolis, creating the world's first fully enclosed, two-level shopping center.

Mademoiselle devotes its entire January issue to Marshall Field's. (see back)

Dayton's Minneapolis begins staging its annual Flower Show as a celebration of spring.

DAYTON'S*
HUDSON'S*

Dayton's and Hudson's combine to form Dayton Hudson Department Store Company.

Marshall Field's

Dayton's, Marshall Field's and Hudson's come together under the Marshall Field's name.

Marshall Field's

Marshall Field's is acquired by Dayton Hudson Corporation.

1946 1954 1962 1969 1985 2000
1952 1956 1963 1984 1990 2001

5%

Dayton's establishes our company tradition of donating 5 percent of federally taxable income to charity.

J. L. Hudson opens the world's largest shopping center, Northland Center in Detroit.

Target is a new idea in discount stores

The Dayton Company enters discount merchandising with the opening of its first Target stores.

The J. L. Hudson Company and the Dayton Company merge to create Dayton Hudson Corporation.

Santabear makes his début. Now a bona fide collector's item, he continues to be an annual sensation.

TARGET CORPORATION

Dayton Hudson Corporation celebrates its name change to Target Corporation and launches its e-commerce capabilities with multiple store-brand Web sites.

name change for all three in 2001 to Marshall Field's. Target, which Dayton started in 1962, emerged as the number one revenue producer for the company and became the corporate name. Following acquisition by Federated Department Stores, the Marshall Field's stores would assume the Macy's name. In 2007, the corporate name was officially changed to Macy's Inc. (Courtesy of Detroit Historical Society.)

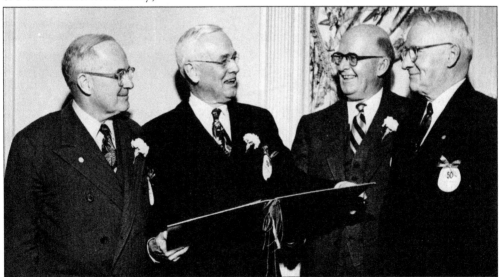

Marking 205 years of combined service to the J.L. Hudson Company, the four Webber brothers pose for this historic photograph. They are, from left to right, Oscar Webber, president; Richard H. Webber, chairman; Joseph L. Webber, vice president; and his twin, James B. Webber Sr., vice president. All held the same posts as officers of Northland Center Inc. (Photograph by David Levine, courtesy of Janet Levine.)

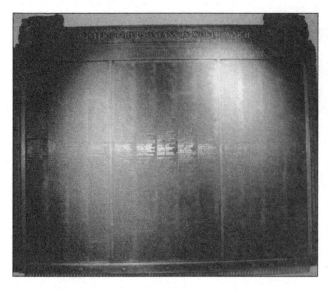

This plaque was dedicated in 1947 at Hudson's downtown Detroit store to honor the 1,146 Hudson employees who served the country in World War II, including the 31, noted with stars, who died. When that store closed in 1983, the plaque was held in storage until being relocated to the Hudson's Northland Center store, which at that time had become Macy's. When Northland closed in 2015, the plaque was relocated and rededicated in the Macy's Oakland Mall store. (Photograph by the author.)

The *Hudsonian* was a monthly employee publication of the J.L. Hudson Company. Shown here are four issues. Clockwise from bottom right are the March 1955 issue celebrating Northland's first birthday, the March 1964 issue celebrating 10 successful years, the January 1972 issue, and an undated issue that highlights Northland Center as a "blueprint for modern merchandising." The magazines salute employees, departments, and activities in photographs and text. (MH.)

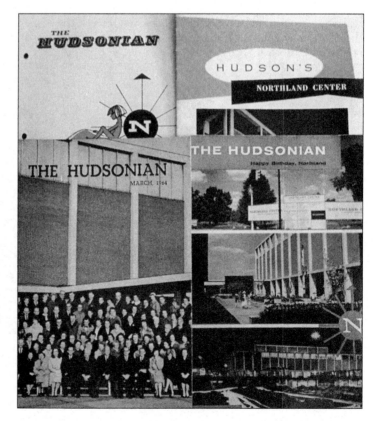

Two

THE GROUNDS

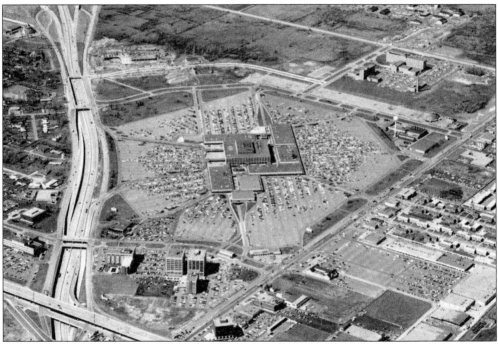

This aerial view from the mid-1950s looks northwest from Eight Mile and Greenfield Roads, illustrating Northland's nearly 90-acre campus and the surrounding area. Eight Mile Road runs along the bottom. At left is M-10, also known as the Lodge and Northwestern Highway. Nine Mile Road is at the top, running from left to right. Running from top right to the bottom middle is Greenfield Road, separating the cities of Southfield and Oak Park. The iconic water tower and the Northland Playhouse dome in the parking lot above it mark the northern boundary of the campus. Above them is Providence Hospital. At the bottom is Stouffer's Northland restaurant, along with the medical and office buildings. The photograph was taken before the Northland Theatre and the J.C. Penney expansion. Note the absence of hotels, apartments, and office buildings from Northland's parking lot north to Nine Mile Road. (Courtesy Gruen Associates.)

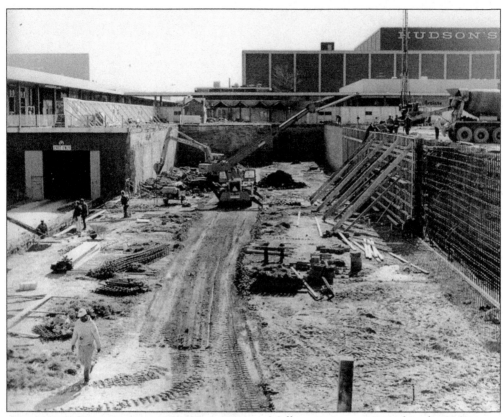

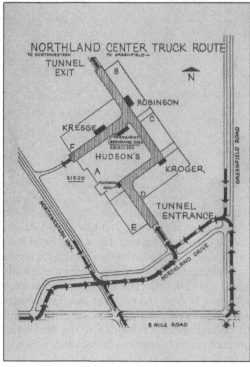

Mall expansion continued in the 1960s and 1970s. This is the north side of the mall with one of the two tunnel exits at left. Artiste Salon is at right. In the 1960s, the new 68,000-square-foot I building was constructed as the 11th separate building in Northland. Some stores moved within the mall and others were new. The 13 stores included B. Dalton Booksellers, Al Harris Men's Wear, Jo-Ann Fabrics, and Charles W. Warren Jewelers. (SPL.)

This diagram of the Northland Center truck route indicates the path by which all trucks entered the tunnel from the southeast end of the mall. The tunnel snakes around and underneath the stores, making deliveries less of a nuisance and obstruction to shoppers and auto traffic. Trucks then exit on their own path north to J.L. Hudson Drive or west toward Northwestern Highway. Security gates and doors at the entrance and exit control access to the grounds. (NA.)

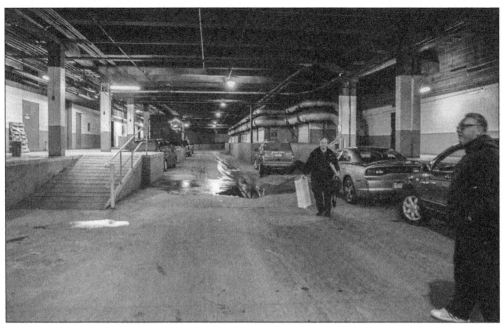

The photograph above, of the inside of the tunnel, was taken prior to a meeting with mall officials. Jerry Naftaly approaches Jim Luxton (right), with Harold Mickel and Aaron Tobin out of view. Ramps are available at each of the door entryways for the convenience of deliveries and unloading for every store. All receiving, loading, and distribution of merchandise comes through this tunnel, underground. Signs by each door clearly mark the names of the business, as shown below. The photographs were taken in March 2015, just prior to the mall closing, which might explain the few remaining business names on the wall. (Both photographs by Aaron Tobin.)

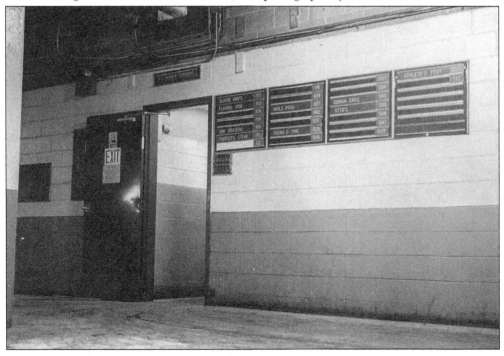

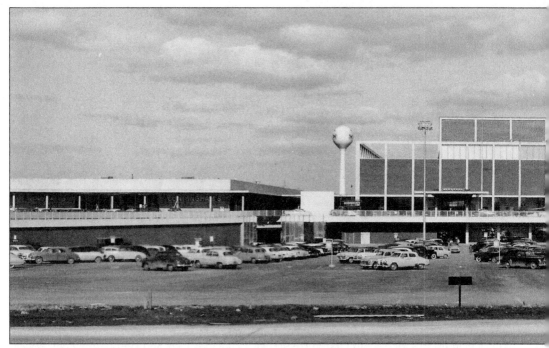

This panorama of Northland's Northwestern Highway side taken just after the 1954 opening shows the original bus loading area. Busses approached on the ramp from the right and exited to the left. Construction continues on the roof at right, the southern portion of the mall known as "E." Stores would include Chandler Shoes, Macauley's, Himelhoch's, and, toward Hudson's, Ross Music and Big Boy. Cunningham's Drugs is on the left corner, with Barna-Bee and Kresge going toward the water tower. Public transportation was provided by the Conant line from the

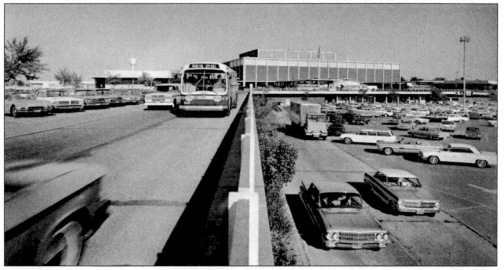

Coach no. 1928, featured in the *1961 General Motors Annual Report*, debuted in 1960 as the company's "new look" coach. The destination sign on the bus reads: "Hamilton—City Hall." This is the Hamilton Line heading back to Detroit City Hall. An older transit bus made by Twin Coach and an older GM coach are in the loading area in back. After one month, all buses to Northland were carrying 6,000 riders on weekdays and about 11,000 on Saturdays. (General Motors.)

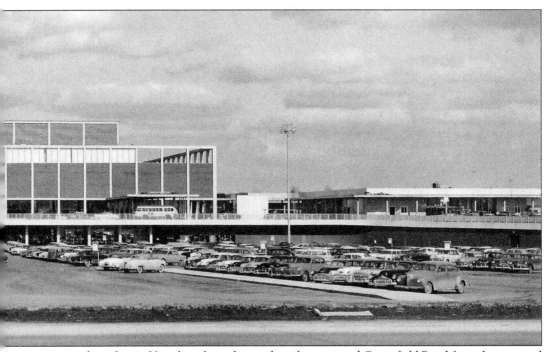

east and northeast, Hamilton from the south and center, and Greenfield Road from the west and northwest, all connecting directly with most other Department of Street Railways (DSR) lines. The DSR became the Detroit Department of Transportation (DDOT) in 1974 with Detroit's newly revised city charter. Southeast Michigan Transportation Authority (SEMTA) operated the suburban lines, and Greyhound offered suburban shuttle service from St. Clair Shores and Farmington. (Photograph by David Levine, courtesy of Janet Levine.)

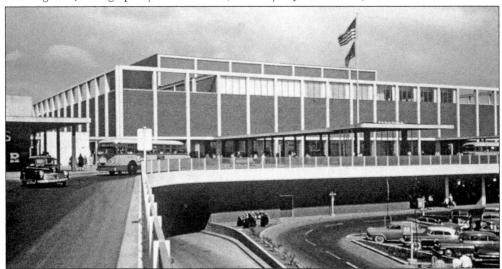

The original Northland bus stop and loading area, with flagpole, provides a distinctive look with one of the new coaches just departing and another arriving. A covered walkway protects the passengers as they exit and walk into Hudson's. Cunningham's Drugs is to the left. *The Boy and Bear* sculpture would be in back of the bus on the right. The Hudson's basement entrance is at the lower level along with package pickup. (Courtesy of Gruen Associates.)

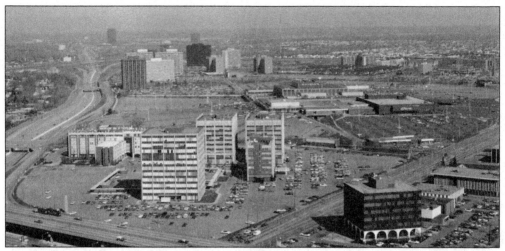

This photograph, taken in 1976, looks northwest from above Eight Mile and Greenfield Roads. The Northland Point development included the medical office building, twin office towers, and the six-floor hotel Northland Inn with a Stouffers restaurant. In the background are Hudson's and the newly added J.C. Penney in the recently enclosed Northland Mall. The lower right corner is in the city of Oak Park. (Photograph by and courtesy of Southfield mayor Kenson J. Siver.)

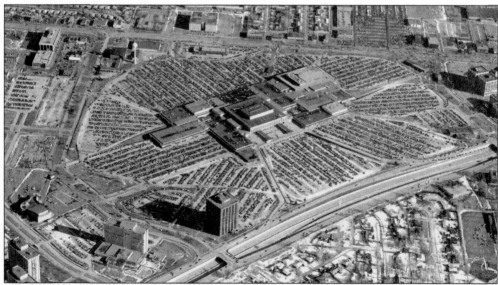

This early, undated aerial shows the dramatic use of nearly all 7,500 parking spaces at Northland Mall. By the 25th anniversary in 1979, there were 9,500 spaces. There are nine paved, clearly marked parking lots. Greenfield Road is at the top of the photograph and Northwestern Highway (Lodge Freeway) is at the bottom. The Northland Theatre is at lower left, and the Northland Playhouse has yet to be built. (Author's collection.)

Three

THE EVENTS AND ACTIVITIES

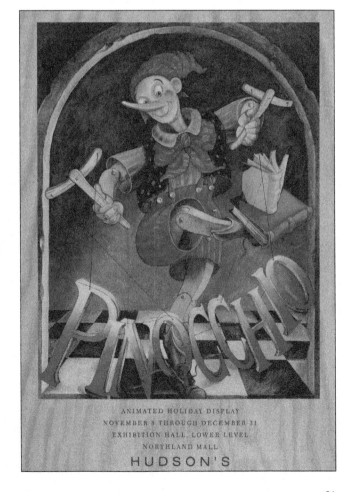

Pinocchio, one of many free, animated holiday displays, came to Northland in 1993. The famous story was featured in more than 20 elaborate displays. Pinocchio's nose even grew right before visitors' eyes. The annual Brandeis Book Sale, ethnic festivals, and square dancing were just some of the popular events. Northland's promotion manager during the 1970s, Mozelle Boyd, said "shopping centers have become more than just places to buy things. Malls have become modern-day cultural and social centers." (MH.)

ANIMATED HOLIDAY DISPLAY
NOVEMBER 8 THROUGH DECEMBER 31
EXHIBITION HALL, LOWER LEVEL
NORTHLAND MALL

HUDSON'S

In 1990, Cinderella's animated display came to Hudson's Northland, at the new exhibition hall, in time for the holidays. After an eight-year hiatus, the classic fairy tale brought back some of the magic that left when the downtown Hudson's closed. More than 11,000 square feet of space was dedicated to the 100 characters in 25 displays. Crowds were big and very happy. It was estimated that a half million people saw the exhibit. Reviews provided by Northland after the exhibit included comments such as "Reminder of Downtown Hudson's—spectacular," "Beautiful! We liked it more than the kid's did," "Hudson's has outdone itself again," and "Magnificent—glad it's at Northland. Every window is fabulous." According to Catherine O'Malley, then Northland's general manager, holiday traffic at the mall was up 20 percent over 1989. "We're establishing new memories and new traditions," she said. (Above, MH; below, courtesy of Detroit Historical Society.)

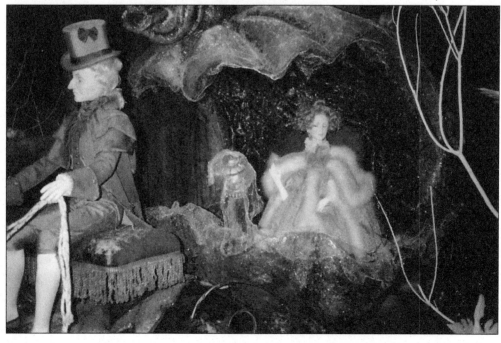

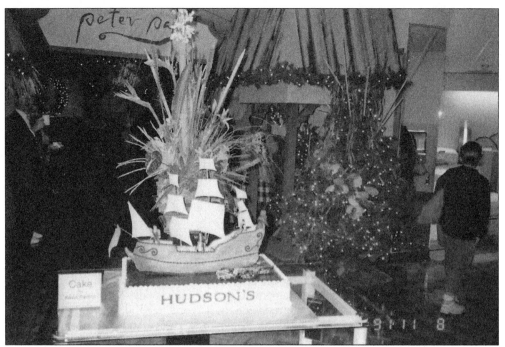

Peter Pan's Neverland exhibit in 1991 was displayed in the lower level exhibit hall of Hudson's Northland. Eighteen detailed scenes with over 150 animated characters retold the story of Peter and Wendy, Captain Hook, Tiger Lily, the crocodile, and others with a summary posted above each panel. Wood creaked as guests walked through the pirate ship. The 11,000-square-foot free exhibit drew 400,000 people. (Courtesy of Detroit Historical Society.)

Northland presented an antique car show in 1966, sponsored by the Veteran Motor Car Club of America. It featured a 1922 Packard Touring car, a 1929 Chrysler Roadster guaranteed to attain at least 75 miles per hour, the first Buick with four-wheel brakes from 1924, and a Huppmobile Aero Touring Sedan from the 1930s. The oldest car in the show was a 1901 Huntingburg, a real "horseless carriage" built by a buggy-maker in Indiana. (NA.)

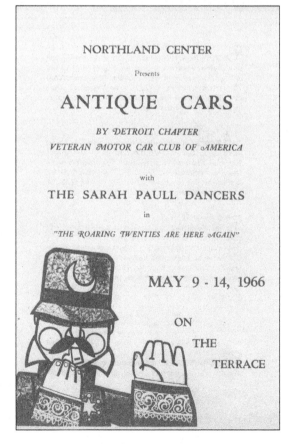

NORTHLAND CENTER

Presents

ANTIQUE CARS

BY DETROIT CHAPTER
VETERAN MOTOR CAR CLUB OF AMERICA

with

THE SARAH PAULL DANCERS

in

"THE ROARING TWENTIES ARE HERE AGAIN"

MAY 9 - 14, 1966

ON

THE

TERRACE

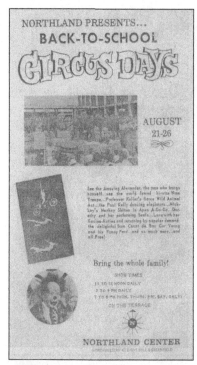

Kids of all ages looked forward to Northland's annual Back to School Circus Days in August. Northland attracted families to the mall with free admission and six days of performances. Whether the circus was held on the terrace (such as in 1966, as shown in the flyer) or in parking lot G in 1972 (as in the image below and on the back cover), crowds filled the grounds. As the flyer indicates, there were high-wire acts, wild animals including lions and the famed dancing elephants that toured with the Shrine Circus, clowns including internationally known Leslie Brooks from Britain, the Bounding Randalls on the trampoline, and dancing poodles. With a ringmaster introducing the acts and free Kiddieland rides, there was something for everyone. And, as long as they were at the center and in a good mood, attendees could go shop at the stores. (Left, NA; below, SPL.)

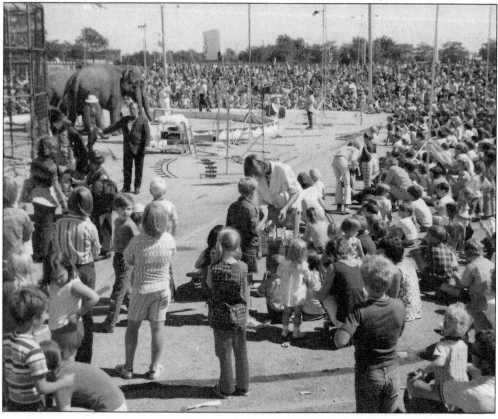

The Sinclair Oil dinosaur exhibit visits Northland in June 1966. In the photograph at right, workers assemble the Tyrannosaurus rex after a long journey. Live T. rexes weighed about seven tons and measured about 40 feet in length and 13 feet tall; they had short forelimbs but were very powerful. In the photograph below, the ankylosaurus was "a walking fortress" at 20 feet long and 6 feet wide. Also on exhibit was a stegosaurus, considered one of the oddest-looking dinosaurs. They ranged from 18 to 25 feet long and weighed four tons. The exhibit appeared at the Chicago World's Fair of 1933–1934, with one million people viewing it each month. The Sinclair dinosaurs were said to "symbolize the great age of the crude oils which are refined into Sinclair oils." However, this was more for advertising and largely a misconception. (Right, SPL; below, courtesy of Mike Grobbel and "Bulletmagnet" at DetroitYes.com.)

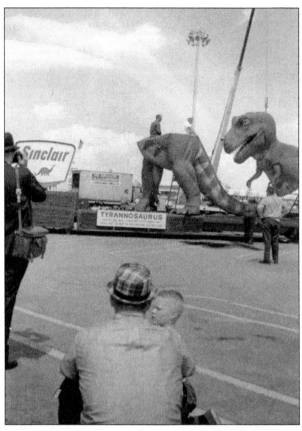

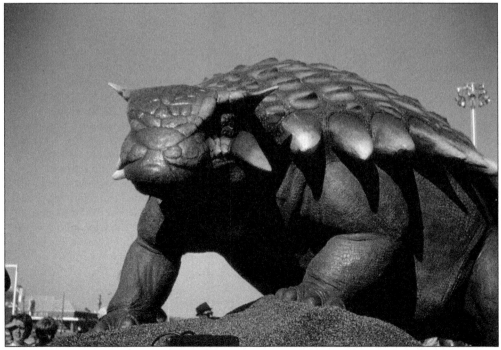

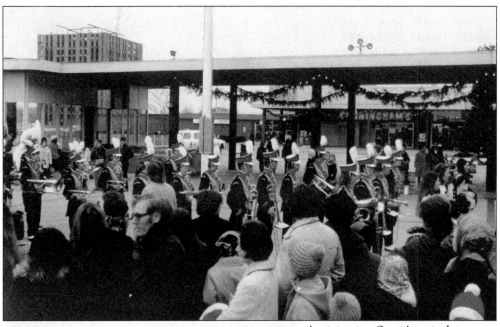

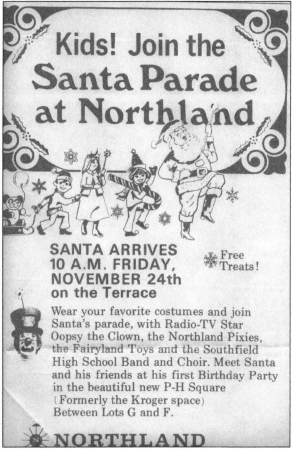

Kids! Join the Santa Parade at Northland

SANTA ARRIVES 10 A.M. FRIDAY, NOVEMBER 24th on the Terrace

❄ Free Treats!

Wear your favorite costumes and join Santa's parade, with Radio-TV Star Oopsy the Clown, the Northland Pixies, the Fairyland Toys and the Southfield High School Band and Choir. Meet Santa and his friends at his first Birthday Party in the beautiful new P-H Square (Formerly the Kroger space) Between Lots G and F.

❄ **NORTHLAND**

Anticipating Santa's arrival on Northland's Terrace on November 24, 1972, the Southfield High School Jays Band waits for the starting word from director Paul Lipa. The band performed Christmas songs and carols, marching throughout the center. Cunningham's Drugs is in back, next to Todd's Clothes. Hudson's Garden Center is at the back left. The Santa Parade was a tradition that began in the downtown Detroit Hudson's and continued in Northland. As the flyer indicates, the event was positioned where Kroger's was located, in the southeast area of the center. Many activities and refreshments were planned. Santa arrived by a husky dogsled team and, following the welcome, the children met with him in the igloo and in Santa's castle. (Above, courtesy of Karla Bellafant; left, NA.)

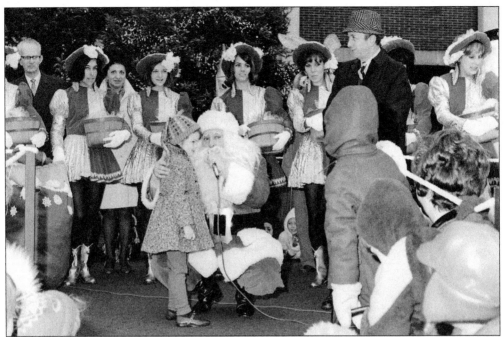

Santa Claus greets the Northland crowd in 1968 and talks with a little girl about what she wants for Christmas. Local TV and radio weathercaster and personality Sonny Eliot, wearing the hat, emcees the event. Local columnist Desiree Cooper noted that Northland was the one place to depend on seeing a black Santa. The center would provide both white and black Santas at different times. (SPL.)

Northland Center recognized the importance of celebrating the traditions of Christmas, Hanukkah, and Kwanzaa. Hanukkah, the Jewish Festival of Lights, was observed with the lighting of candles and music performed by violinist Mark Komissarov. The Salvation Army Brass Ensemble performed Christmas music as part of a traditional celebration. The celebration of Kwanzaa included a performance by the Traditional Dancers of Detroit from Marygrove College. Northland decorated exits and courtyards with colorful displays. (MH.)

Hanukkah
Sunday, December 6

Hanukkah, also known as the Feast of Lights and the Festival of Dedication, has been celebrated by Jews for twenty-one centuries. It is a holiday that commemorates the victory of the Maccabees as they were triumphant in reclaiming the Temple of Jerusalem.

The main feature of Hanukkah is the kindling of lights on eight successive nights of the holiday. The flames reflect the glow of the religious freedom the Maccabees fought for. Observation of Hanukkah will begin at sundown on Saturday, December 19.

Enjoy the music of Hanukkah performed by violinist Mark Komissarov from 12:00 - 1:00 p.m., Townhouse area, lower level.

Christmas
Saturday, December 12

Christmas is a time of merriment and feasting, a time for celebrating the birth of Christ and a time for indulging in all the traditional pleasures: The Christmas Tree, gifts from Santa Claus, turkey and all the fixings, cards and carols.

Christmas is also a time to reaffirm peace on earth and goodwill toward men. Christmas is always celebrated on December 25.

The Salvation Army Brass Ensemble presents the sounds of Christmas from 12:00 - 2:00 p.m., Townhouse area, lower level.

Kwanzaa
Saturday, December 19

Kwanzaa is a week long holiday of African cultural heritage, created 26 years ago, and now observed by more than five million Americans. Kwanzaa means "first fruits" in Swahili. Beginning the day after Christmas, Kwanzaa is a unique and growing celebration which takes elements from a wide range of African harvest festivals.

Celebrate Kwanzaa with the Traditional Dancers of Detroit from Marygrove College under the direction of Penny Godboldo from 1:00 - 2:00 p.m., Marketplace, lower level.

Hudson's
Bridal Show & Fair

Northland Center provided a variety of unique shows—from fashion shows for men, women, and children, to bridal, music, and shows on outdoor cooking and gardening. The first program at the mall, held just after it opened in 1954, was the fashion show Suburban Living on Parade, bringing together the merchants. Mall managers Pat Hobar, Catherine O'Malley, and John Bemis, among others, promoted the center and the merchants, bringing in more traffic. (MH.)

In 1960, Dr. Harold Roland, his wife, Rhoda, son Marc, and daughter Marcie spent a week in a fallout shelter at Northland's terrace. The family, on display through a window in their 14-by-10-foot corrugated steel shelter, demonstrated a potential experience during the Cold War after a possible Soviet nuclear attack, with Rhoda keeping a daily log. Thirty-eight families applied and were psychologically evaluated. The key was misplaced, causing a wait while officials broke the lock. Over 1,000 people cheered when the Rolands emerged successfully and feeling good. (Courtesy of Marcie Roland Lebow.)

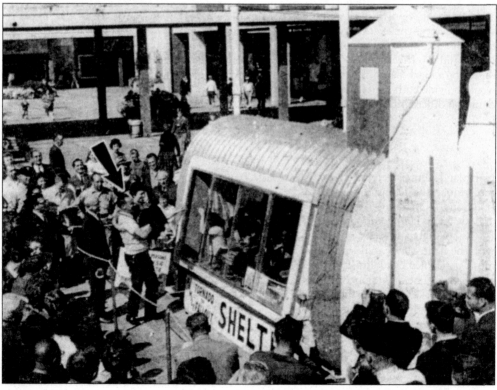

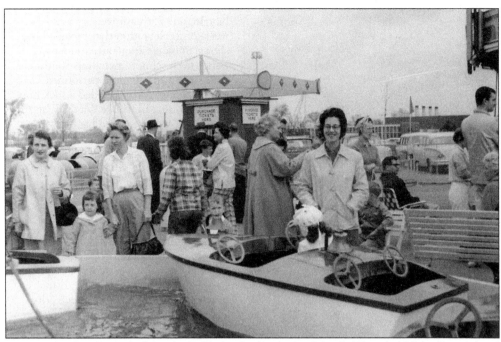

Every spring from 1954 on brought Kiddieland rides to Northland. (This should not be confused with Kiddieland near the West Side Drive-In on Eight Mile Road, or Edgewater Park and elsewhere, or the children's store of the same name in Oak Park.) Rides were set up in parking lot D, next to Fisher Wallpaper and Paint and around the corner from Robinson Furniture. Shown here are just two of the rides in 1960. Above, Susan Brody watches as daughter Cindi is ready to shove off in her boat. The ticket booth is in the background. David Brody, an active resident of Oak Park, looks like he is having as much fun as daughter Cindi on the helicopter ride below. Other rides included a merry-go-round, a Tilt-A-Whirl, and a small roller coaster. (Both, David Brody collection, courtesy of Cindi Brody.)

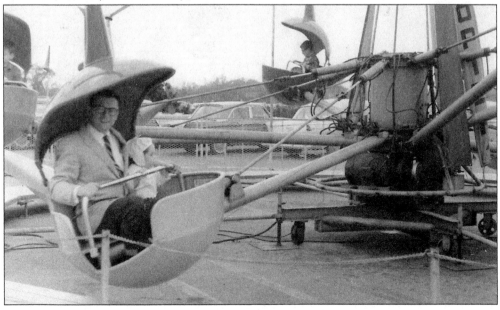

Northland's 25th anniversary was a two-week-long celebration that included live shows, music, fashion, art, and movies. Bands from schools including Southfield, Oak Park, and Mumford performed. A fifties-themed party included a sock hop, Oscar-winning films like *On the Waterfront*, a Mickey Mouse–themed birthday party, and an exhibit of more than 100 Norman Rockwell paintings. An audiovisual display showed the first 25 years of Northland's history. (Courtesy of Jerry Webber.)

The 25th anniversary celebration also included The Game Show, a live combination of several TV game shows, emceed by local promoter George Young. Prizes of cash and Northland shopping sprees were offered. Comedian Eric Servis (right) welcomes local celebrity and aluminum-siding czar Mr. Belvedere (Maurice Lezell of Oak Park), whose slogan was "We do good work!" CKLW disc jockey Dick Purtan also appeared. (NA.)

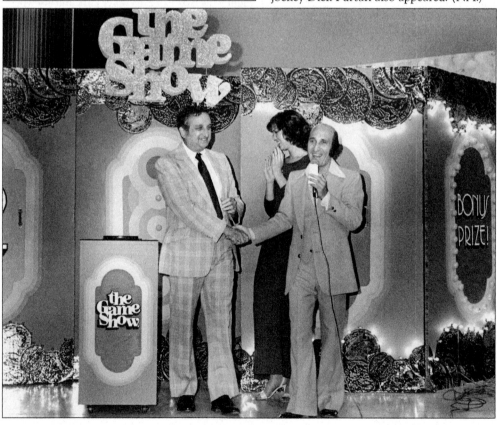

Four

THE SCULPTURES AND ART

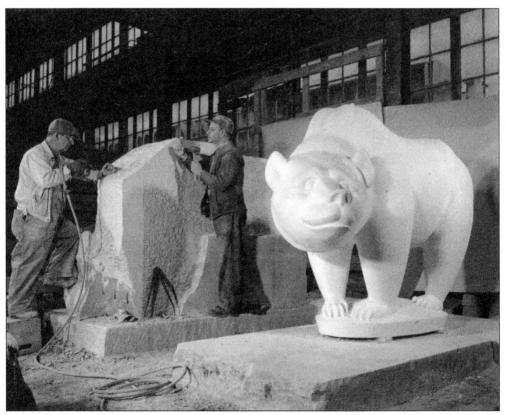

Marshall M. Fredericks's *The Boy and Bear* is well known as Northland's trademark. Here in Fredericks's Royal Oak studio, stonecutters from Meier Cut Stone carve out the form of the bear from Indiana limestone. The sculpture took three years to complete. Fredericks's credo was to bring happiness to others through his sculptures, and shopping centers provided a way to expose his sculptures to more people. (Marshall M. Fredericks Sculpture Museum.)

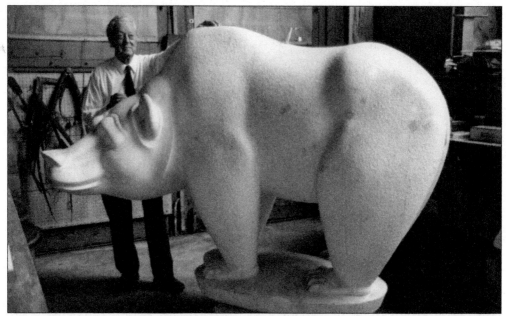

Marshall M. Fredericks poses with the plaster model of the bear in his Royal Oak Studio. Marshall's son Carl describes his father as "having a love for children. He had a fundamental philosophy to make pieces that would bring out the happiness in children. The bear has a gentle smile and lowered down snout for the kids to rub. He's welcoming and friendly and my father wanted it to be a friendly encounter." (Marshall M. Fredericks Sculpture Museum.)

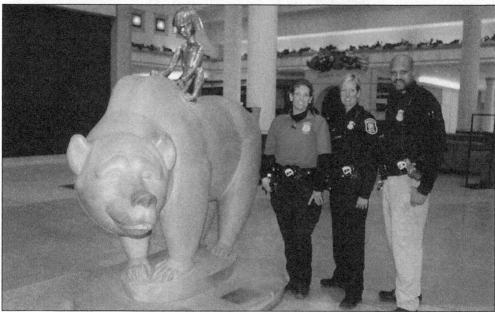

From left to right, officers Kelly Pate, Kelly Buckberry, and Devlin Williams pose with *The Boy and Bear* one last time during a tour of the facilities. Chief Eric Hawkins assigned the detail to accompany two groups in conjunction with their regular rounds. They provided interesting insight into the mall, the tenants, and the people. Donations were made to the Friends of Southfield Police Fund in appreciation of their time and service. (Photograph by the author.)

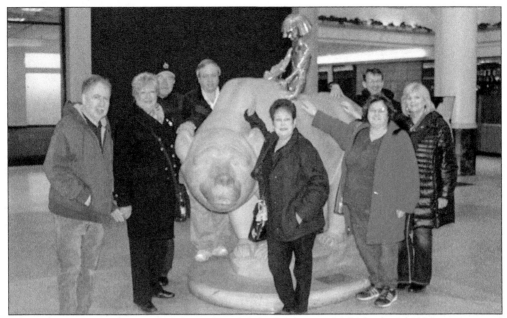

Facebook group members toured the mall and shared memories of the businesses that once graced the halls. They pause here for one of the final photographs with *The Boy and Bear*. Pictured are, from left to right, Dr. David Torby, Patricia Ruhland, Richard Ruhland, Jerry Naftaly, Kathy Scharff, Paul Willis, Joyce Lenhoff Torby, and Sheryl Young. *The Boy and Bear* is done in bronze casting with gold plating. (Photograph by Officer Kelly Buckberry.)

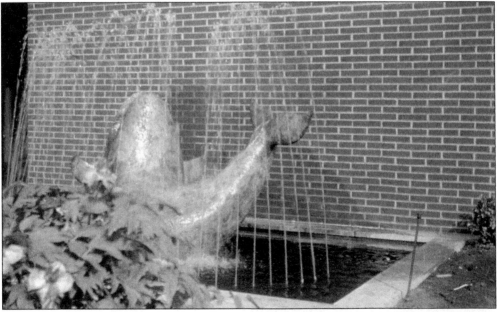

Moby Dick by Joseph Anthony McDonnell is swimming in his own pool, seen here in the Fountain Court in July 1971. Considered one of the more beloved characters at Northland, he continuously spouted water, typical of a huge whale and much to the appreciation and thrill of the visitors. McDonnell also created *Woman with Fish*, made of fiberglass and bronze, cast in Italy, and placed in the North Mall. (SPL.)

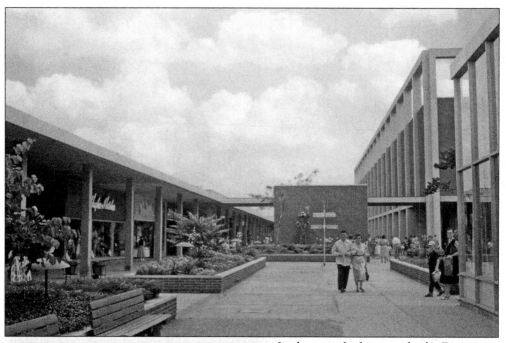

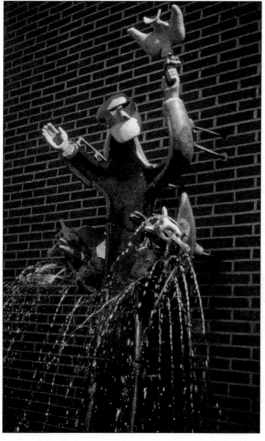

In this view looking south, the Fountain Court features a garden with redbuds, rhododendrons, and azaleas. In the center, the *Noah* water sculpture/fountain is by Lily Saarinen, who was one of the six original sculptors commissioned by Hudson's. This courtyard is just outside Hughes & Hatcher and Thom McAn, with Phillips just past this on the left. The Maple House is on the right, with Hudson's to the far right. The photograph at left, taken in 1956, is a close-up of the 10-foot-high *Noah*. (Above, courtesy of Gruen Associates; left, courtesy of Mike Grobbel and "Bulletmagnet" at DetroitYes.com.)

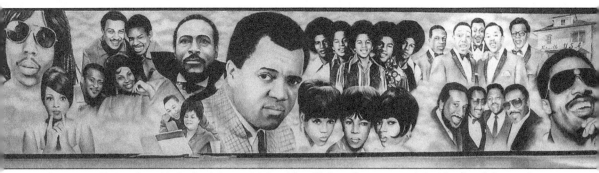

Begun in September 2013, the Motown Mural by Clifton Perry was 10 feet high, 45 feet wide, and took five months to complete. Attached to the J.C. Penney wall, it showcased some popular Motown acts: from left to right, Rick James, Tammi Terrell, Gladys Knight and the Pips, Marvin Gaye, Smokey Robinson, Esther Gordy (Hitsville Museum), Berry Gordy, the Jackson 5, the Supremes, the Four Tops, the Temptations, and Stevie Wonder. (Photograph by Aaron Tobin.)

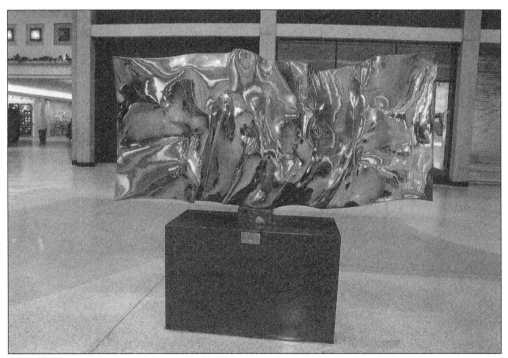

Crowd by Italy's Gio Pomodoro is polished bronze and measures approximately eight feet long, two feet wide, and six feet high. It was not one of the original six works commissioned by Hudson's, and several different size and shape versions of *Crowd* were created in the 1960s. In *Sculpture Magazine*, Pomodoro called the works "surfaces under tension," a metaphor for the varying tensions of society. It is one of nine pieces purchased by the City of Southfield in 2015. (Photograph by the author.)

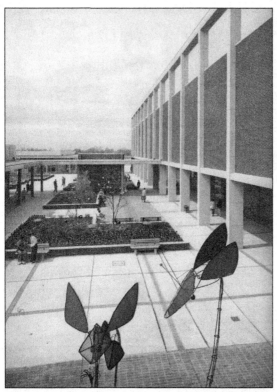

Detroit sculptor Malcolm Moran, creator of the *Giraffe Family*, was one of the original six sculptors commissioned for Northland. According to the June 1954 *Architectural Forum*, the giraffes are "copper covered steel wires attached in abstract triangles arranged to resist stresses and strains. Their spots are stained glass made in Germany and each yellow, blue and red has a range of 35 shades." Moran also built the *Fish Mobile* fountain (page 37). He said his ideas "are strictly from imagination. I haven't looked at a giraffe since I was a child." He inspected the steel and stained glass by climbing a ladder. It is said that mall staff hauled the necks down nightly to protect them from wind damage. Because of the popularity of the giraffes, more than 9,000 miniatures were made and sold as souvenirs at Northland. (Both photographs by Malcolm Moran, courtesy of Douglas M. Steiner.)

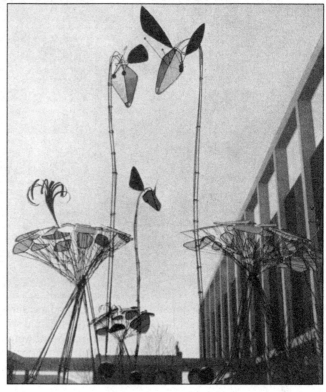

The Cat that Swallowed the Canary by Arthur Kraft is a devilish piece of art made of brass rods with glass eyes. The bird's heart, a prism, is fluttering inside the cat's stomach, as tradition would have it. Created in brass, the poor canary is the work of Gwen Lux. It was moved indoors when the mall was enclosed. Kraft also created *Peacock*, a brass rod sculpture with beautiful plumage, located in the Fountain Court (SPL.)

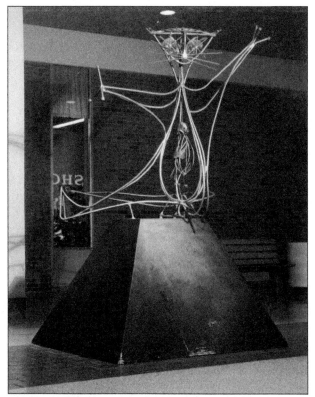

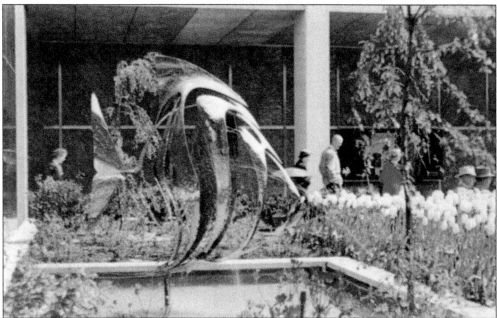

The *Fish Mobile* fountain by Malcolm Moran is a nickel-plated copper sculpture sparkled with silver and marble, seen here in the springtime in the late 1950s. When the fountain was working, the segments would "move restlessly and fluidly like a fish in the sea," making twists and turns. A reporter noted that it "swims in the wind." (SPL.)

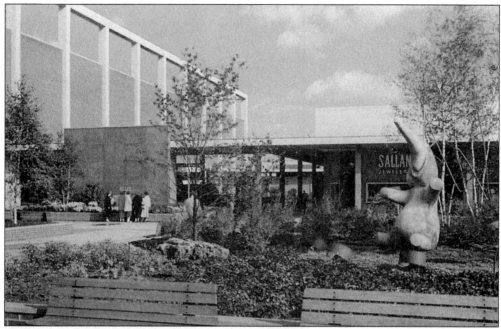

This view looks east through the Great Lakes Court with the cast stone *Baby Elephant* sculpture by Arthur Kraft in the foreground seen happily frolicking in the flower bed. Sallan Jewelers and Sanders are in the background, to the right. On the left, women admire the wall sculpture. On the other side is one of the seven information points with mall directories, phones, and water fountains all protected under a canopy. (Courtesy of Jeff Wasilewski.)

The 22-foot-high wood and painted steel *Totem Pole* by Gwen Lux was one of those easily remembered destination sites, as in "meet me at the totem pole." Located between Kresge, Building F on the left, and the north side of Hudson's in the North Court (with the water tower in the background), it was another perfect spot to relax and enjoy the flower beds and one's friends. (Courtesy of Ray White.)

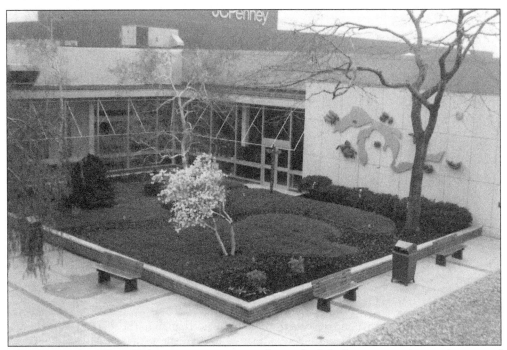

The *Great Lakes Water Hole* is a ceramic map sculpture by Lily Saarinen outlining the state of Michigan and the Great Lakes. Saarinen, an established sculptor and artist, studied at Cranbrook and married architect Eero Saarinen, who was teaching at Cranbrook. The smaller figurines that Saarinen added, shown in detail in the photograph below, were said to work well surrounding the larger work. These smaller traces of wildlife are done in stylized ceramic contour metal and help to portray the natural beauty of the state. The *Totem Pole* and the bridge were added later. (Above, NA; below, photograph by the author.)

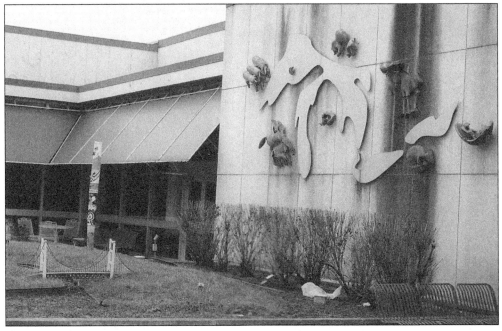

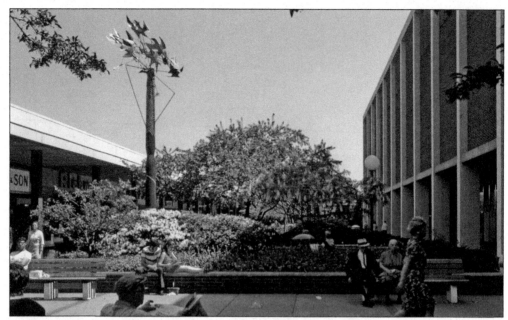

In this view looking south along the courtyard from the north mall to the south mall, *Bird Flight* provides a relaxing background for shoppers who want to enjoy the good weather. Sculptor Gwen Lux used enameled copper on painted wood for the mobile sculpture, which is 25 feet high. To the left, Father & Son, Richman Brothers, Kinney Shoes, and Raimi Curtains are down the line. (Courtesy of Gruen Associates.)

This is the main entrance from parking lot E, almost in the direct middle of the mall's eastern side, which flows into the northeast entrance of Hudson's. This view facing southeast looks through the simple but attractive courtyard—furnished with overhangs, flowers, and benches—to Brothers Delicatessen, with Dunns Cameras and United Shirt to the right. (Courtesy of Gruen Associates.)

Five

THE BUSINESSES

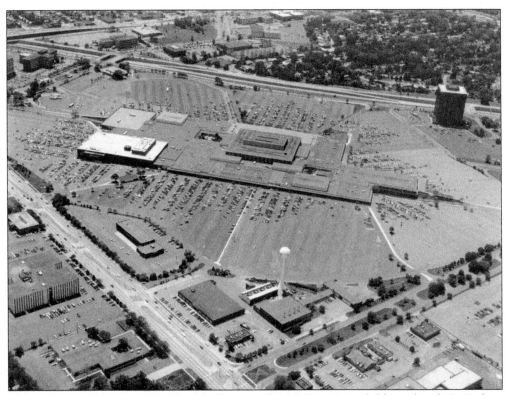

This 1990s aerial view of Northland looking southwest from Greenfield Road and J.L Hudson Drive overlooks the water tower and maintenance building. The 14-story Tower 14 Office Center, now occupied by HAP, is at upper right. (COS.)

The Abbey Lounge Cocktails
and RestaurantB-3
Albert's, Ladies & Junior Apparel......C-18
Alexander & Hornung, Meats..........D-5
Appearance Shop,
Northland ConcourseX stairs
Artiste Beauty Salon.................F-37
Auditorium,
Community ConcourseY stairs
Awrey BakeriesD-7
Bache & Co., Inc., Stockbrokers......B-7
Baker's Shoes.......................D-19
Barber Shop (Hamby's)
Community ConcourseY stairs
Barna-Bee Children's ShopF-11
Barricini CandiesG-7
A. S. Beck Shoes....................F-14
Bernard's Beauty Salon..............G-35
Bessenger's, Window Shades..........E-5
Best & Co., Women's & Children's
Fashion ApparelH-Bldg.
Better Made Potato Chips,
Medical ConcourseZ stairs
Big Boy Restaurant..................E-29
Brennan's MillineryE-37
Brother's Restaurant &
DelicatessenC-1
Chandler's Shoes....................E-22
Community Key Shop,
Community ConcourseY stairs
Coney Island Lunch Bar,
Northland ConcourseX stairs
Corey's Jewelry, Inc................E-30
Coronet CardsT-1
Cunningham's Drugs.................F-7
Dairy & Nut House
Community ConcourseY stairs
Dairy & Nut House...................T-2
The Detroit Bank & Trust Co........E-16
AnnexB-1
The Detroit Edison Co...............B-10
Morris Disner & Son, Men's Clothier E-25
Dunham's Inc., Sporting GoodsB-12
Dunn's Camera & Art Supplies.........C-4

Elliott Travel Service,
Northland Concourse............X stairs
Englander Furniture Shops..........D-35
Fanny Farmer Candy.................F-25
Father & Son Shoes..................C-11
Fischer Gift Shop....................G-3
Flagg Bros. Shoes...................F-27
Flowers by Maskell...................D-1
Franklin Simon, Women's Apparel.....E-18
Harry Garden, Jewelry Repairs &
Sales—Northland Concourse.....X stairs
Max Green's Men's Wear, Inc........F-23
L. G. Haig Peacock Room Shoes......F-13
Harty, Austin & Jones, (Attorneys)
Northland ConcourseX stairs
Himelhoch's, Women's Children's
Specialty Shop....................E-11
Hot 'N' Kold Shops.................B-16
Hudson's..............................A
Hudson's Car Care Center
Northland Drive and Greenfield
Hudson's Garden Center..............O
Hudson's Pick-up-Station,
Lower Level, Below the Terrace.....A
Hughes, Hatcher, Suffrin............B-23
Kay CorsetiereD-32
Kelly Girl Service, Inc.
Northland ConcourseX stairs
G. R. Kinney Shoes.................C-14
KresgeF-20
KrogerD-12
Lady Orva Hosiery
Medical ConcourseZ stairs
Lane Bryant, Women's ClothingB-14
Thom McAn Shoes..................B-26
McBryde Boot Shop.................G-15
Macauley's, Stationery..............B-32
Maple House Restaurant..............N
Marianne, Ladies ApparelF-16
Maternity ModesE-31
Marwil Book Co.,
Community ConcourseY stairs
Medical Offices, Medical Concourse Z stairs
Clinical X-Ray Service

From the early years, Northland distributed this directory alphabetically listing the business names and locations in the center. These letter and number combinations coincide with the map on the next page. Many businesses changed locations, especially when the mall was enclosed in the spring of 1975. Several businesses were initially on the concourse level and moved up to street level. (Both, MH.)

Fryfogle Medical Research Lab.
Fryfogle, James D., M.D.
Hergt, Klaus, M.D.
Polentz, Charles P., M.D.
Stevens, Charles H., M.D. F.A.C.S.
Dr. Sherman A. Mendelsohn, Foot
Specialist, Community ConcourseY stairs
Meyer Jewelry Co...................C-10
Miami Bake Shoppe..................G-5
Modern Stamp & Coin Shop,
Northland ConcourseX stairs
Jerry Morse—
Gentlemen's AttireG-29
Nadon's, Junior Sportswear, et cetera...E-24
National Reproductions Corporation
Community ConcourseBC-9
Northland Center Offices,
Community Concourse............Y stairs
Northland Drug Co..................C-22
Northland Duplicate Bridge,
Northland Concourse............X stairs
Northland Mummp....................Lot "K"
Northland Theatre
Joseph L. Hudson Drive
Northland Tobacco Shop,
Community Concourse...........Y stairs
Northland Underwriters, Inc.,
Northland Concourse............X stairs
Northland Watch & Clock Service.....E-33
Optometrist, Stein, Dr. Benj. H.,
Northland Concourse............X stairs
Palmer's Sandwich Shop.............D-4
Peck & PeckG-31
Peter's Small Size Ladies Wear.........E-39
Phillips Florsheim Shoes............G-19
Phillips Shoes......................B-28
Dr. Edward C. Pintzuk, Foot
Specialist, Community ConcourseY stairs
Police Office,
Community ConcourseY stairs
Medical ConcourseZ stairs
Post Office,
Northland Concourse............X stairs

Mary Radcliffe Employment Agency
Northland Concourse.............X stairs
Raimi's CurtainsC-16
Reid & Cool, Consulting Engineers
Medical Concourse.............Z stairs
Rest Rooms,
Community ConcourseY stairs
Richman Bros., Men's Clothing........C-12
Robinson FurnitureB-20
Rose JewelersF-33
Ross Music Co......................E-32
Sallan JewelersD-27
Salt Cellar — Northland Concourse ..X stairs
SandersD-30
Schiller MillineryE-27
Sero's RestaurantG-37
Shoe Tree, Inc......................E-8
Dr. Donald A. Simon, Dentist—
Medical ConcourseZ stairs
Singer Sewing Center...............B-35
Singer Sewing Room
Northland Concourse...........X stairs
Special Events Center........Garden Terrace
Spencer ShoesE-35
Stevens, Women's SportswearD-25
Dorothy Stofer,
Community ConcourseY stairs
Stouffer's RestaurantS-Bldg.
Surwin's — Women's Specialty Shop ..G-25
Susan Ives — Up's 'N' Down's
Women's SportswearG-21
Suzy HatsF-24
Tall-Eez Shoe Co...................G-1
Tall Girls ShopE-7
Teen Man Store for BoysG-11
Tie RakF-30
Todd's, Hollywood ClothesF-10
Trueman Girl — Medical Concourse ..Z stairs
United Shirt DistributorsC-7
Van Horn's, Men's WearC-19
Winkelman's Ladies WearD-21
Wright Kay, JewelersE-14
WWJ Radio,
Medical ConcourseZ stairs
Zwieback's, Suburban, Ladies WearD-17

42

Directory of NORTHLAND STORES and BUILDING LOCATIONS

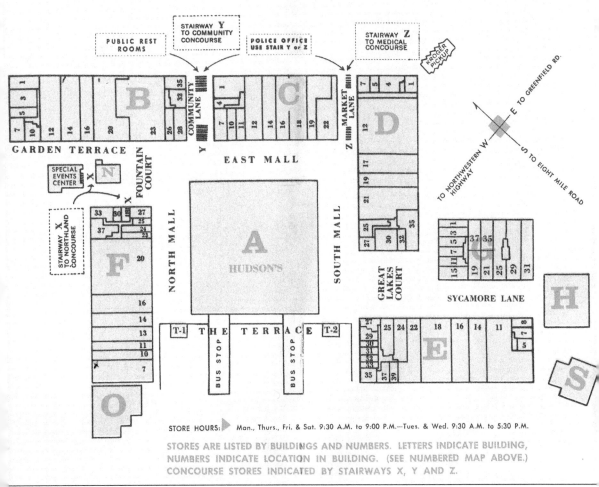

STORE HOURS: ▶ Mon., Thurs., Fri. & Sat. 9:30 A.M. to 9:00 P.M.—Tues. & Wed. 9:30 A.M. to 5:30 P.M.

STORES ARE LISTED BY BUILDINGS AND NUMBERS. LETTERS INDICATE BUILDING, NUMBERS INDICATE LOCATION IN BUILDING. (SEE NUMBERED MAP ABOVE.) CONCOURSE STORES INDICATED BY STAIRWAYS X, Y AND Z.

The directory of the Northland Stores is depicted straighter than the mall is positioned for easier viewing. The bus stop and terrace are at the bottom of the image. Greenfield Road would be at the top, with Eight Mile Road to the right. The names of the mall sections and courtyards, including Great Lakes Court, Garden Terrace, and Fountain Court, are labeled. Stairways note the entry to the concourse level. (MH.)

43

Northland Center Stores

NOW OPEN OR UNDER CONSTRUCTION

Albert's	Enggass Jewelry Co.	Marwil Book Co.
Appearance Shop	Englander Furniture Shops	Maskell Flowers, Inc.
Artiste Beauty Salon		Maxwell's Toys & Records
Awrey Bakeries	Fanny Farmer Candy	
Baker's Shoes	Father & Son Shoes	Northland Center, Inc., Offices
Barna-Bee Children's Shop	Fintex	
	Fisher Wall Paper & Paint Co.	Northland Studio
A. S. Beck Shoes		Palmer's Sandwich Shop
Better Made Potato Chips	Great Lakes Seafood & Poultry	Peter Pan Snack Shop
Bloetscher's Meats		Phillips Shoes
Brennan	Nat Greene Maternity Modes	Queen Cleaners & Dyers
Brothers Delicatessen	Himelhoch's	Raimi's Curtains
Center Music Shop	Hot 'N' Kold Shops	Robelle Shops
Chandler's Shoes	Household Finance Corporation	Robinson Furniture
The Cotton Shop		Sallan Jewelers
Cunningham's	Hudson's Northland	Sanders
del Gaudio Gifts	Hughes & Hatcher	Schillers Millinery
The Detroit Bank	G. R. Kinney Shoes	Stouffer's
The Detroit Free Press	Kline's	Suzy Hats
The Detroit News	Kresge	United Shirt Distributors
Morris Disner & Sons	Kroger	Van Horn's
Dube's Barber Shop	Thom McAn	Wilbur-Rogers
Dunns Camera & Hobby Supply	Macauley's	Winkelman's
Elliott Travel Service	Mari-Ann	Wright Kay
		Zuieback's

As listed on this page from the official March 1954 media kit, 65 of the original 80 Northland Center stores were either open or under construction. Northland was considered a complete suburban shopping town, and the business neighbors and competitors provided a uniquely diversified shopping experience including six food stores, a bank, four restaurants, jewelry stores, shoe and clothing stores for children, men, and women, drugstores, and a supermarket. Everything that Hudson's offered at its downtown parent store was available at its Northland branch. (NA.)

This first in a series of tenant bulletins, dated August 3, 1953, was issued by Northland Center Inc. In it, 14 tenants, including Englander, Hudson's, Hughes & Hatcher, Kresge, and Sanders—some of the major retailers of the day—discuss what store hours would become official policy when the mall opened some seven months hence. Mall management issued updates weekly, drawing attention to issues and concerns, including construction detours and signage. (NA.)

This convenient diagram illustrates Northland Center's full grounds, including the entrances and exits for each parking lot. The bottom of the directory shows Stouffer's Northland Inn, Northland Towers, and the Medical Center. The Mummp had already replaced the Northland Playhouse at upper right, just below Providence Hospital. The full map shows bus lines that have direct runs to Northland. (NA)

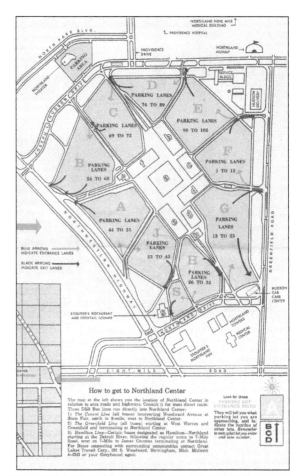

This aerial view of Northland looking northeast from Northwestern Highway was taken prior to the mall enclosure. To the left of the water tower at top center is the Northland Playhouse. The city of Oak Park is at the top, above the water tower. From the tower going north along Greenfield Road, the property is all vacant. No office buildings or retail structures had been developed at the time. (Courtesy of Detroit Historical Society.)

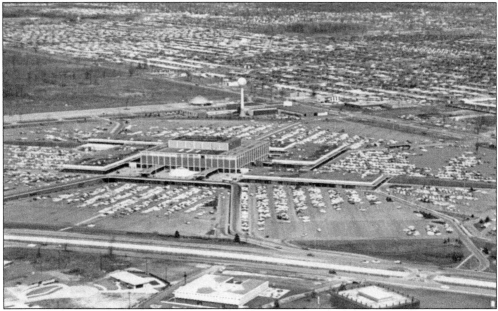

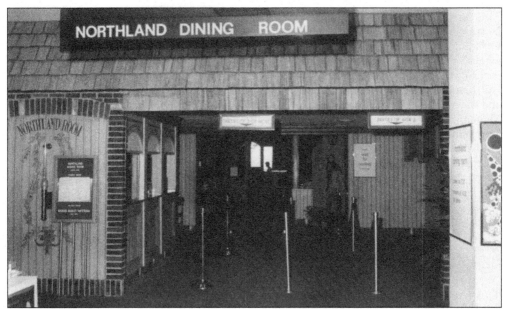

Hudson's Northland Dining Room on the fourth level featured hostess seating with full waitress service by a staff of 50 and seating for 325 guests. The dining area provided 10,000 square feet, and more than 1,200 lunches were served daily. Guests enjoyed the same time-honored menu items that were featured at the downtown Hudson's, including the favorite Maurice salad, shown on the opposite page. Luncheon fashion shows, like those held downtown, were also presented in Northland every Monday during the 1950s and 1960s. McCall's-Seventeen back-to-school fashion shows were also held in the dining room. In 1958, Miss America Marilyn Van Derbur made a personal appearance. Gunter brought his fall wool fashions to the dining room in 1970. Newscaster Lowell Thomas spoke in 1976. As additional Hudson's and other malls were opened, the Northland Dining Room business declined, and it closed in 1997. The Wicker Basket Cafeteria was on the lower level. (Both, MH.)

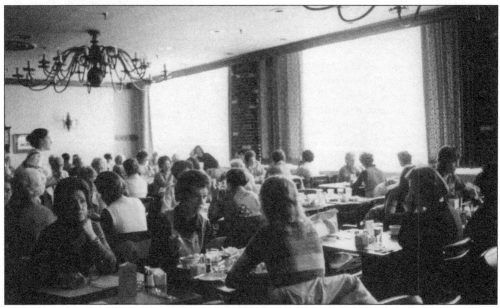

The Maurice salad was a favorite among diners at Hudson's, and this tradition continues at Macy's restaurants. This photograph illustrates the main ingredients: strips of ham and turkey breast, Swiss cheese, sweet gherkins, shredded iceberg lettuce, and pimento-stuffed green olives. The dressing includes white vinegar, lemon juice, onion juice, sugar Dijon mustard, dry mustard, mayonnaise, fresh parsley, hard-cooked egg, and salt. (Courtesy of Macy's chefs and public relations, Laura Vitale and Geoff Barden.)

The Hudson's Dining Room menu cover described the modern sculptures dotting the grounds of Northland. However, the focus was on the inside: In March 1954, coffee was 10¢, oyster stew was 70¢, and apple pie a la mode was 35¢. The most expensive items were breaded pork tenderloin and a fresh crabflake salad in vegetable nest, each $1.70. Hudson's slowly evolved away from traditional standard items with more up-to-date dishes. The Maurice salad remained. (NA.)

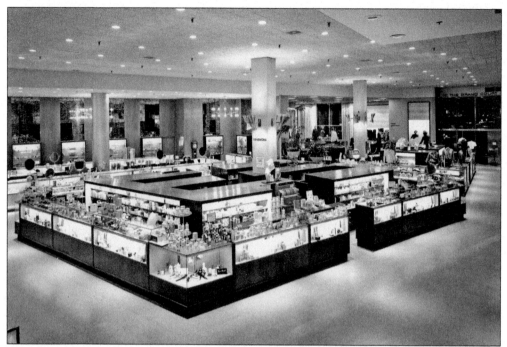

This area of Hudson's main floor features the cosmetic counter, jewelry, and women's accessories in brightly-lit display cases. There are wide aisles and high ceilings, along with the ability for the customer to get close and touch the merchandise. The budget sportswear department is at the rear, by the door. (Courtesy of Gruen Associates.)

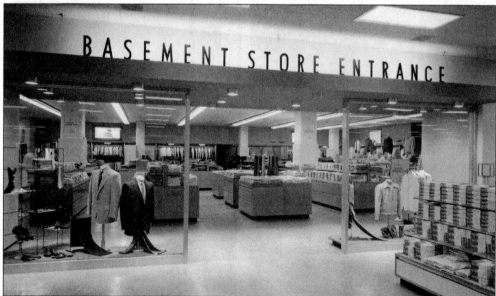

This is one of three entrances to the Hudson's Basement Store, on the L-shaped, lower level. It had 189,000 square feet, including 45,000 square feet in separately merchandised basement store items. The entrance was underneath the bus area on the northwestern highway side and next to the Hudson's pickup station. The basement level was built around the truck tunnel for easier access to deliveries. (Photograph by David Levine, courtesy of Janet Levine.)

In 1985, the Santabear was first offered for sale. The white plush bear created by Dayton-Hudson's senior toy buyer Paul Starkey became an instant hit. It is estimated that over 400,000 bears were sold throughout the chain in the first few days. Beginning in 1986, the year was added to the knit cap and it was an annual, must-have collector's item. (Courtesy of Detroit Historical Society.)

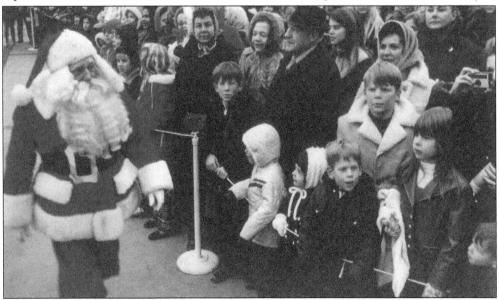

Santa, also known as Rube Weiss, arrives at the Northland Terrace on November 24, 1972. Weiss was the official Santa for many years in the J.L Hudson Thanksgiving Parade. He was well known for his distinctive voice and career in Detroit radio and television that spanned 50 years, beginning in the 1940s. He acted in *The Lone Ranger* and *The Green Hornet* radio shows, among others, and was the voice of Detroit Dragway's "Sunday! Sunday! at Detroit Dragway" commercial in the 1960s. (Courtesy of Iain MacGregor.)

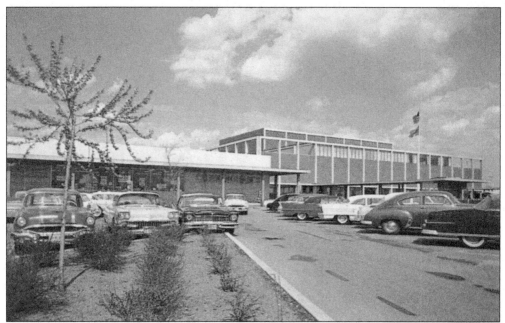

Cunningham's Northland store was the 107th in the chain and one of the largest of its new Pic N' Pay self-service models. Built on a corner, the 7,000-square-foot store had an attractive green front. There were almost 30 departments in the Cunningham's store selling merchandise, a prescription counter, and a stainless steel soda and snack fountain. One of the store's slogans was "We're a Drug Store and a Whole Lot More." Founded in 1889, the chain saw a number of mergers under Nate Shapiro, who had assumed control after merging his drug chain with Cunningham's. By the late 1950s, it became the largest drugstore chain in Michigan. Perry Drug Stores and then Rite-Aid eventually took over the stores that remained through the 1980s and 1990s. (Above, courtesy of Jeff Wasilewski; below, COS.)

This Kresge's March 1954 ad marking the opening of the company's 55th store in the metro area offers bargains including parakeets for $4.98. The main floor of Kresge's included 17,000 square feet, a 78-stool soda fountain, 23-foot stand-up luncheon bar, "quickie" snack bar, and chairs for shoppers to relax. The basement was used for merchandise stocks. A balcony along the east mall floor housed store offices. The photo booth and 45-rpm records were popular. Five-and-10-cent items included coffee for a nickel. Twelve-foot-high window panels faced the parking lot, allowing people to look in.

This Hiawatha Card Co. postcard shows the view along the North Mall, with Hudson's on the right and Kresge, with distinctive gold lettering on its red facade, on the left. *The Tortoise*, made of beaten copper, raises its head in the foreground, with people relaxing on benches in the open-air courtyard. In the background are the *Totem Pole*, the Fountain Court, and the iconic Northland water tower in the distance. (Courtesy of Jeff Wasilewski.)

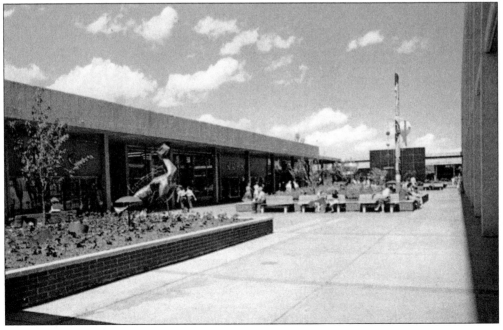

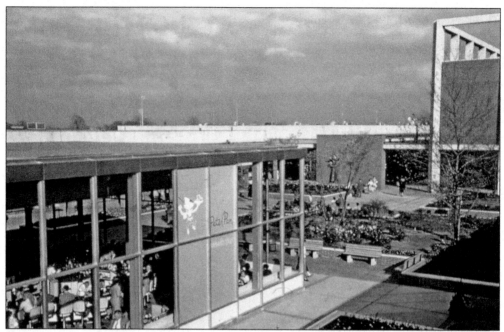

The Peter Pan Snack Bar was unique as a stand-alone building along the Fountain Court, considered one of the busiest parts of the center. The large picture windows on three sides, upholstered counter stools with backs (visible in the photograph), and four upholstered booths for comfort allowed patrons to eat, relax, and still enjoy the view. (Courtesy of Gruen Associates.)

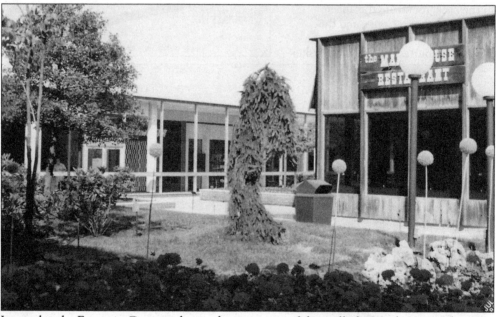

Located at the Fountain Court in the northeast section of the mall, the Maple House, shown in 1974, was the place to go for pancakes, waffles, omelets, and other refreshments. Billed as "Oakland County's traditional family restaurants serving the finest in custom-made food, breakfast lunch and dinner," it was open seven days a week, from 7:00 a.m., year-round. A self-serve post office on the north wall, Rose Jewelers, and Northland Hatter were neighbors. (NA.)

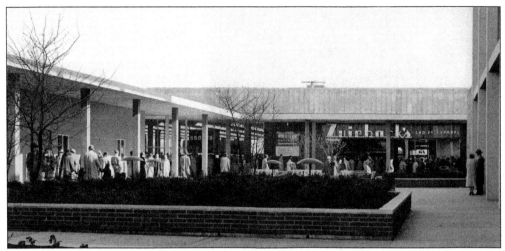

This view looks south from the East Mall, with Zuieback's next to Kroger Foods. This is Zuieback's eighth store specializing in women's merchandise, dresses, coats, gloves, and accessories. The company celebrated the grand opening of its Northland store in 1954 by harking back to its Detroit roots, where Zuieback's was founded in 1911. Its modern window display included authentic costumes from that era. (Photograph by David Levine, courtesy of Janet Levine.)

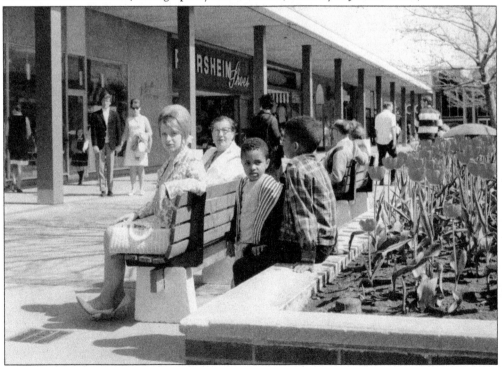

The tulips are in bloom in this 1960s springtime view looking down Sycamore Lane from the Great Lakes Court. Resting on the benches in the courtyard, people enjoy the weather and watch others walk by. The businesses on the left include McBryde Boot Shops, Florsheim, Susan Ives Up's 'N' Down's Women's Sportswear, and Best & Co. in the distance. Best & Co., which opened on March 1, 1963, had two locations selling clothes for boys, girls, misses, women, and juniors. (SPL.)

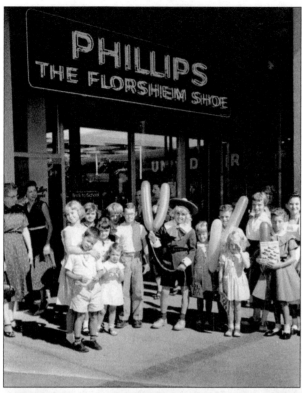

Phillip Eisenshtadt opened the first Phillips Shoes in 1925 at the corner of Hasting and Farnsworth Streets in Detroit. A neighbor, Sonny Elliot, would do commercials for the chain in the 1970s. Phillip's son Harry, along with Irv Weinberg, managed the new Northland store that opened in 1954. Phillip's son Norman continued to manage the Detroit stores until the Eastland store opened in 1957. The third generation, Harry's son Jerry, started at Northland in 1961. The Phillips formula for success helped grow the chain to 22 stores. The original men's department was 800 square feet and was among the largest-volume men's shoe departments in the country. Buster Brown appeared at the grand opening of the store with his dog, Tige (not pictured). (Both, courtesy of Jerry Eisenshtadt.)

Phillips Shoes is seen here from the courtyard. In the background are United Shirt, Dunns, and Brother's. With its continuing success in the shoe business, Phillips opened a second store in 1967 in the same mall, managed by Jerry Eisenshtadt. Sonny Elliot, J.P. McCarthy, and other celebrities shopped at the store due to its large variety. Shopper turned employee Eugene Lumberg became Oak Park's prosecuting attorney. Florsheim (the sign spells it wrong), Hush Puppies, and Dexter were popular shoe brands. (Courtesy of Jerry Eisenshtadt.)

Minutes From Town

People attending conventions and other visitors to Detroit can easily and quickly reach Northland Center via the John Lodge Expressway. Northland is actually only a matter of minutes from Detroit's Civic Center and the city's business section.

NORTHLAND

N C CENTER

OPEN

9:30 a.m. — 5:30 p.m.
Monday through Wednesday
9:30 a.m. — 9:00 p.m.
Thursday through Saturday

EXCITING
NORTHLAND

NORTHWESTERN HIGHWAY AND EIGHT MILE ROAD
IN THE
CITY OF SOUTHFIELD
MICHIGAN
ADJACENT TO NORTHWEST DETROIT

This ad promotes Northland as only minutes away from downtown Detroit and the Civic Center district. It appears in the book *Victor Gruen: From Urban Shop to New City* by Prof. Alex Wall. Northland was a tourist destination, with visitors to the area saying they must go see the "World's Largest Shopping Center." Postcards of Northland were on sale everywhere. (Courtesy of Alex Wall.)

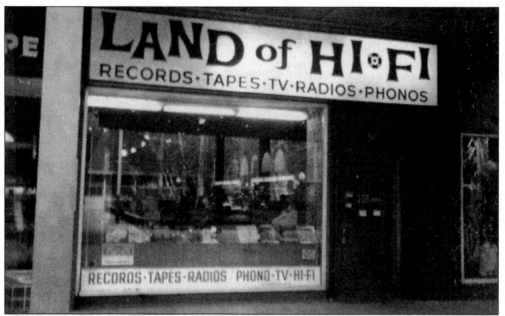

From early beginnings renting space in his brother's Detroit hardware store, Chuck Bassin grew Land of Hi-Fi into a highly respected name. Northland's store, one of seven locations, helped make it the top national Panasonic dealer during the 1970s. Bassin also supplied Hudson's when their inventory was low. Land of Hi-Fi's Northland store, with a sound room, 2,000 square feet of retail, and 1,000 square feet of basement storage, enjoyed a reputation for its extensive jazz LP library. (COS.)

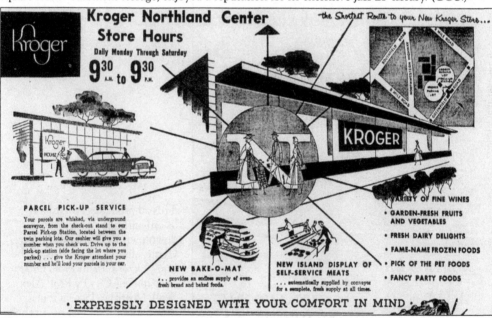

This Kroger ad from the same time as the opening of its Northland store in 1954 shows the variety and many advantages of shopping at Kroger. The store's parcel pickup service was very advanced for the day and a convenience that Kroger emphasized. This was equal to the conveyor system and package pickup offered by Hudson's. The ad notes that Kroger's corner location provided access from two lots, F and G.

Better Made's Northland store, in the concourse, received fresh merchandise daily from its company plant, pictured here illustrating the chip-making process, and packaged it in the store. The main products were regular potato chips, shoestring-style, popcorn, cheese curls, and peanuts. A rack "pick and pay system" allowed customers to select products and pay at the counter. Cathy Gusmano said her father, cofounder Peter Cipriano, had a dream of making and selling potato chips, but they had to be "better made," hence the name. (Courtesy of Cathy Gusmano, Better Made Snacks.)

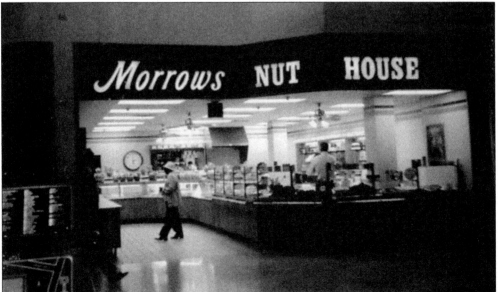

Nationally known Morrow's Nuts, pictured here in the early 1970s, featured specialty gift boxes of hand-dipped chocolates and chocolate-covered nuts. Licorice whips, sour apple drops, pecans, and jumbo redskins were also popular. During World War II, Morrow's customers shipped cans of mixed nuts overseas to the soldiers for $2.50 each. The Dairy & Nut House on the Terrace sold chocolate-covered frozen bananas, dipped and covered with nuts, as well as malts, shakes, caramel corn, and popcorn. (COS.)

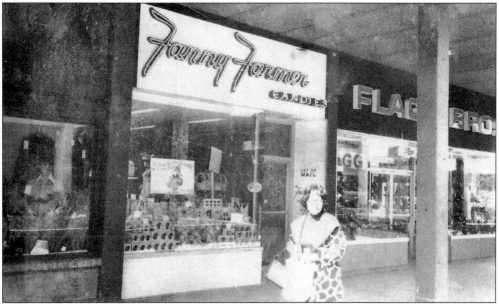

The Fanny Farmer candy store carried a full selection of fresh, daily prepared candies and nutmeats, complete with personalized assortments and worldwide shipping available. Located in the North Mall, it had a different look from other Fanny Farmer locations, with muted pastels, new displays, and counters to make it more modern. The colorful neon sign above the door was an innovation. Fanny Farmer's famous secord buttercream chocolate Easter egg with the golden "yolk" at $1.25 per pound was a favorite that the candy company started selling in Detroit in 1935. (COS.)

This was store 153 for the family-run Awrey Bakeries, which began 44 years prior to the Northland store's opening in 1954. Awrey is one of the iconic names in metro Detroit, like Faygo and Sanders. The Awrey family is said to have pioneered the in-store bakery in supermarkets along with freestanding stores with fresh products, such as baked goods, pastries, cakes, and the famous windmill cookies. Business peaked in the 1950s, and the company filed for bankruptcy in 2005 after 95 years, but Awrey recently emerged under new ownership. (COS.)

The Sanders candy store, pictured in this 1974 photograph, was located north of Hudson's, next to Sallan Jewelers by the Great Lakes Court. Sanders, celebrating its 79th year when Northland opened, was founded by Fred Sanders on June 17, 1875. The Northland store carried a full line of candy, bakery, wedding cakes, and other specialties. In addition to carry-out services, there was a seated, low-stool fountain area that served lunches, ice cream, and beverages. The store design featured a stainless steel fountain, oak bakery and candy cases, and black–antique gray trim. Popular treats included the hot fudge cream puff, the Bumpy Cake, and fudge and classic caramel toppings. The Morley Candy Company bought the Sanders name and recipes in 2002, and Sanders retail shops have since been opening in the Detroit area and on Mackinac Island. This ad is from April 1954. (Above, COS; right, NA.)

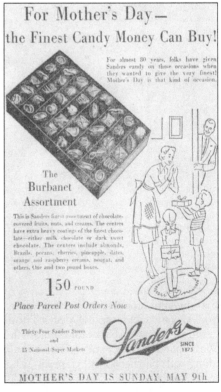

For Mother's Day —
the Finest Candy Money Can Buy!

For almost 80 years, folks have given Sanders candy on those occasions when they wanted to give the very finest! Mother's Day is that kind of occasion.

The Burbanet Assortment

This is Sanders finest assortment of chocolate-covered fruits, nuts, and creams. The centers have extra heavy coatings of the finest chocolate—either milk chocolate or dark sweet chocolate. The centers include almonds, Brazils, pecans, cherries, pineapple, dates, orange and raspberry creams, nougat, and others. One and two pound boxes.

1 50 POUND

Place Parcel Post Orders Now

Thirty-Four Sanders Stores
and
15 National Super Markets

Sanders SINCE 1875

MOTHER'S DAY IS SUNDAY, MAY 9th

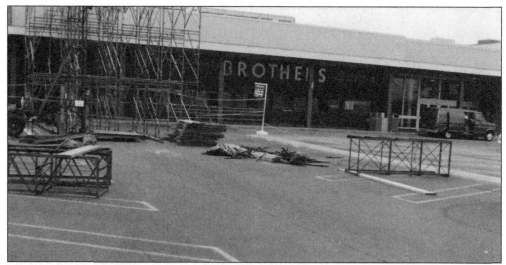

Brothers Delicatessen (of brothers Sam and Lou Horenstein) opened in 1954 on a corner of the mall's eastern side at C-1. The deli and restaurant specialized in overstuffed corned-beef and turkey sandwiches along with traditional deli foods and trays of meats, dill pickles, coleslaw, desserts, and beverages. With seating for 160, the deli had a separate counter that handled carry-out orders. Sam and Lou, along with brother Max, served in the Army in World War II before coming back to open the Brothers Deli on Dexter. (NA.)

Serving light lunches with prompt service, Palmer's Sandwich Shop opened in 1954 by Kroger's and Alexander & Hornung Meats. The dining area included very modern chairs and upholstered counter seats with backs for comfort. John Palmer operated the Palmer Lunch Restaurant on West Lafayette Street and opened a chain of four restaurants called the Palmer Sandwich Shops along with partner John Lymperis. When both Palmer and Lymperis retired, son Ed Lymperis took over operations. This photograph is from 1974. (COS.)

This ad that ran just prior to the grand opening in March 1954 proclaims: "Welcome to the World's Largest Shopping Center." "A complete shopping town," it announces with pride. Most of the stores listed along the left side were open or almost open. Shoppers drove to the area, watching the progress and anticipating this day. Whether people were coming by car or bus, adequate arrangements had been made. It was billed as "the biggest shoppers' parking lot in the world" and did not disappoint.

The Elias brothers—Fred, John, and Louis—bought and operated what was known as the first official franchisee of the Big Boy chain of restaurants, mostly located in Michigan and Ohio, in the early 1950s and owned it until about 2000. The Northland restaurant was located by the Terrace near *The Boy and Bear*. Signature menu items included the classic Big Boy: two thin hamburger patties on a three-layer bun, lettuce, cheese, and special sauce. Also popular were the Slim Jim and Brawny Lad. (COS.)

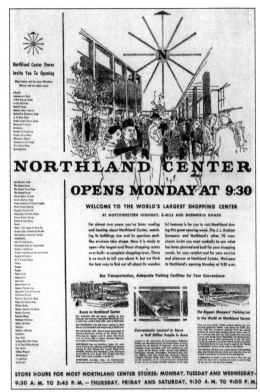

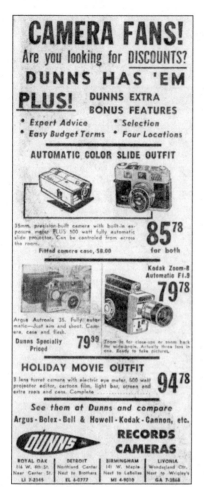

Macauley's Office Products began in 1869 with Jack Macauley's great-grandfather James F. Macauley in the Union Depot in Detroit. In 1872, brother W.T. Macauley joined, adding fireworks and bicycles. With J.L. Hudson's expansion on Woodward, the second generation joined the family business. In 1912, Henry Ford brought son Edsel to the store and bought fireworks. In 1954, Macauley's opened the Northland store and expanded into other centers. In 1961, Jack Macauley, the fourth generation, succeeded his father, Arthur. Jack's son Mark, the fifth generation, took the helm in the early 1990s. In 1995, the company was acquired by Staples Inc.

The Northland location was Dunns Camera and Hobby Supply's third store, joining Birmingham and Royal Oak, where the business was established in 1944. It sold a complete line of photographic equipment, tape recorders, and hobby supplies. Dunns offered its own photofinishing plant with eight-hour service. Nationally known and award-winning photojournalist/author Linda Solomon noted that her father, Danny Rappaport, bought her one of her first single-lens reflex cameras at Dunns. That launched a distinguished career and the nationally acclaimed Pictures of Hope program. (COS.)

Glenn Slocum was a district manager for Hallmark in metro Detroit and his son, Bill, owned and managed the two stores pictured. Glenn's Hallmark, shown above in 1975, was located at A-3, next to Corey's. The Hallmark store below was known as T1, due to its position on the Terrace since the mid-1950s. When the mall was enclosed in 1975, T1 was closed. (Both, COS.)

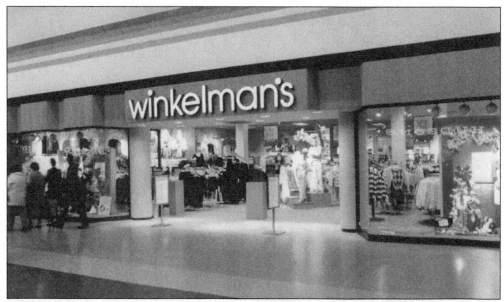

This was Winkelman's largest store. This photograph from the 1980s shows the large 50-foot front; the store had a depth of 150 feet and 31 fitting rooms. This location also had the largest millinery department and most complete alteration department in the Winkelman women's fashion and clothing chain. Seventy-five people were initially employed at the Northland store. (SPL.)

Marianne, a women's clothing store, was part of Petrie Stores, which owned hundreds of discount clothing stores under various names. Marianne was located next to Kresge's and carried women's shirts, blouses, sweaters, and lingerie in a décor of rose-colored walls and carpeting. This was a branch of the downtown Detroit store. Other stores operated in Chicago and Philadelphia, and the company had been in business for 20 years prior to the opening of Northland in 1954. (COS.)

B. Siegel sold a variety of fashions, including sportswear, dresses, intimate apparel, children's wear, and shoes in its seven stores. The store was originally called Heyns Bazaar, until Benjamin Siegel bought the company in the late 1800s. B. Siegel closed its Northland store in 1984, one week after closing its Eastland store. The company had celebrated its 100th anniversary in March 1981 but filed for bankruptcy that August and was sold to a local investor's group. (SPL.)

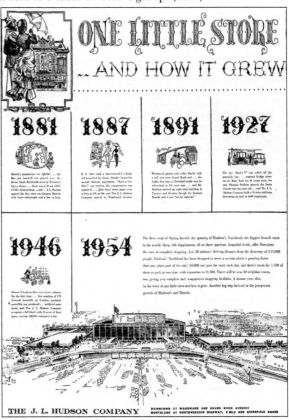

This 1954 ad details Hudson's growth from 1881 with J.L. Hudson's first store. That first year, Detroit's population was 130,000 and the city's first professional baseball team was the Detroit Wolverines. In 1887, when the company moved to Woodward, Hudson's sold boy's short pants for 50¢. In 1891, Hudson opened an eight-story building. In 1927, the last Ford Model T rolled off the assembly line, the Babe hit 60 home runs, Olympia Stadium opened, and the 16-story Hudson's addition was built. By 1946, Hudson's served 100,000 customers a day. In 1954, Northland was built. This was a historic time for the company.

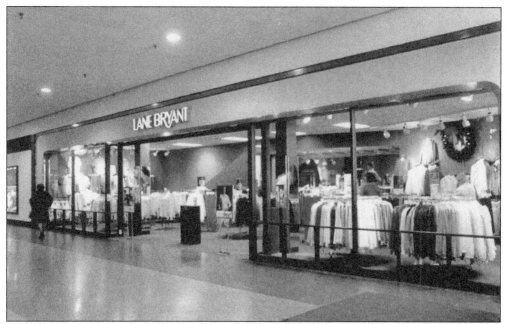

Lane Bryant opened its Northland store on November 22, 1954, in the northeast Garden Terrace section. Self-serve counters, rather than showcases, offered an informal atmosphere. The one-story store with a mezzanine included specialties such as maternity clothes and a value section. This photograph is from the 1980s. Lane Bryant is a nationally recognized name in plus-size clothing, with an eye to fashion, style, size, and fit. (SPL.)

The Limited was located in the northwest section of the mall, across from Kresge's and Marianne. Founded in 1963 in Columbus, Ohio, the Limited is a fashion retailer offering apparel designed to help the modern woman succeed. This photograph is from the 1980s. (SPL.)

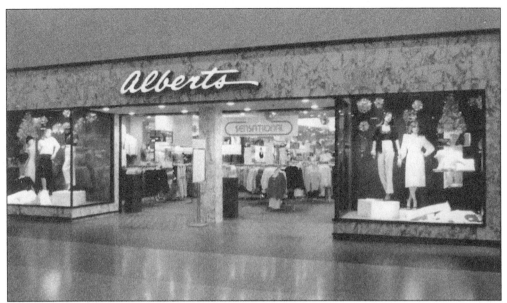

In 1933, Albert Schwartz founded Alberts in Detroit. In 1954, the chain's sixth Detroit-area location became an original tenant at Northland. Alberts incorporated in 1958 and grew to a chain of 70 stores specializing in women's ready-to-wear, national-brand merchandise. This store had 5,600 square feet on the ground floor. Albert, his son Ernest, and Ernest's brother-in-law Bill Klinsky all participated in running the Northland store. In 1970, Alcove, a subsidiary, opened near Alberts and was headed by Ron Schwartz, Albert's grandson. Selling trendier, higher-priced merchandise and featuring a mirrored, tunnel entrance, it was hip for the 1970s. In 1983, Mark Schwartz, Ron's brother and Albert's grandson, started retailer Scott Gregory, a high-fashion women's store named for his two sons. It was located around the corner from the other two family stores, Alberts and Alcove, and all three were respected names. Three generations of the Schwartz family owned stores at Northland. (Both, SPL.)

Dr. Benjamin Stein relocated his optometry office to the concourse level of Northland in 1956, then to the north side, and lastly to the former Big Boy location. When Dr. Ben passed away in 1984, his sons, master opticians Stuart and Robert; his widow, Marion; sister Holly Stein Sholder; brother Dr. Edward Stein; and Dr. Mark Lavine continued the practice. With Northland's closure, they relocated in Southfield to continue providing service to a fourth generation of patients. (Photograph by the author.)

WWJ 950 AM radio had studios in the medical concourse and also this temporary studio. It was near Father and Sons, with the *Birds* sculpture in the background and the flowers blooming in the foreground. Bob Maxwell broadcast his show More Enjoyable Music from this location. Maxwell was a well-known disc jockey at WWJ and WJLB. Northland sponsored the 100 Beautiful Cars exhibit on the East Mall and Terrace. For those who may not recognize it, the sign is a replica of a vinyl 45-rpm record. (Courtesy of Ray White.)

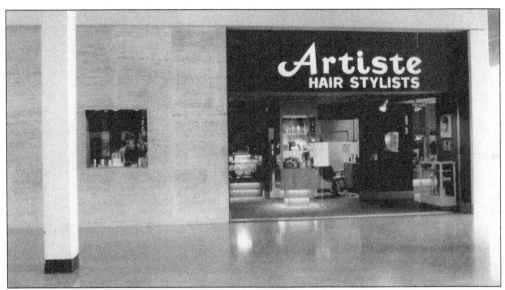

This photograph of the Artiste Hair Stylists located near Hudson's Fountain Court was taken in the 1980s. One of the original Northland tenants, this was the newest of the six salons owned by the Artiste Permanent Wave Company, with other locations including Detroit and Boston. The salon specialized in permanent waving and tinting. Its design was modern and contemporary with an unusual and dramatic center floor arrangement. Artiste had 20 operators initially. (SPL.)

Top of the Line salon was opened in 1997 by founders Frank Usher Jr., John Mitchell, and Steve Hardwick Jr. Near Target's parking lot entrance on the mall's former east side Terrace, the salon was opposite the dentist and Dr. Stein's offices. Family-owned, it has catered to local personalities and professionals with many haircut styles. Under owner Irene Green, it relocated in Southfield to continue successful operations and serve its loyal customers. (Photograph by the author.)

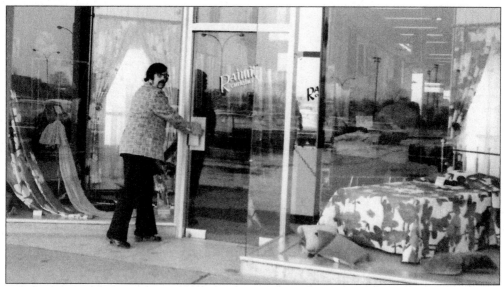

Raimi's Curtains, an original tenant, was founded in 1924. Seen here in 1974, Raimi's sold curtains, bedspreads, and shower sets in 6,000 square feet of floor space in the fourth and largest store in the chain. Founder and president Sylvia Raimi, along with her husband, Jacob, and son Abraham, ran the chain with bookkeeper Bill Williams and store manager Art Rosenberg. Alcove bedroom displays had beige carpeting and vinyl tile floors. (Courtesy of Gail Raimi Dreyfuss.)

Founded by Ralph Schiller in 1917, Schiller's survived the Great Depression of the 1930s by offering quality-priced hats and handbags at reasonable prices. Ralph Schiller's sons took over when he passed away in 1940. The Schiller brothers expanded the chain into Northland as an original tenant. They supplied department stores and specialty shops so successfully that the stores became a division of S.S. Kresge in 1972 after accounting for 25 percent of Kresge's hat and handbag business. (Courtesy of Gruen Associates.)

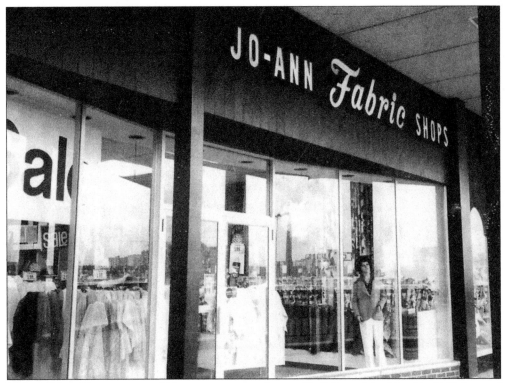

Jo-Ann Fabric Shops was one of 13 stores to occupy the new I building at Northland in 1968. Located by the tunnel exit on the north side of the mall, Jo-Ann was near Lane Bryant. Headquartered near Akron, Ohio, Jo-Ann Fabrics is the nation's largest specialty retailer of fabrics and crafts and currently operates over 850 stores in 49 states. (COS.)

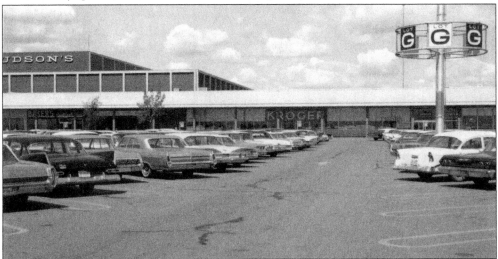

The view from parking lot G, the southeast corner of the center, includes Baker's Shoes at far left, Zuieback's, Kroger, and Maskell Flowers on the right, and Hudson's in the background. Kroger had 32,000 square feet at the opening, in the store and a lower level, which was used for stock, meat handling, loading docks, and conveyors. Kroger offered 10 checkouts, along with a unique package pickup that gained national attention. (Courtesy of Tom Frank, Kroger Real Estate.)

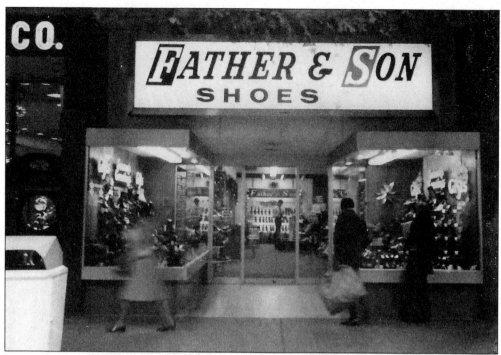

Featuring a complete line of shoes for men and boys, Father & Son Shoes was the 29th in the national chain, owned by Endicott and Johnson Corporation. In April 1953, it was among the first 30 stores to sign leases, joining Queen Cleaners, Sanders, Raimi's, and Phillips Shoes. Advertisements in the 1950s included testimonials from actual fathers who had worn the shoes as kids and then bought them for their own sons. The store was located near Brother's Deli. (COS.)

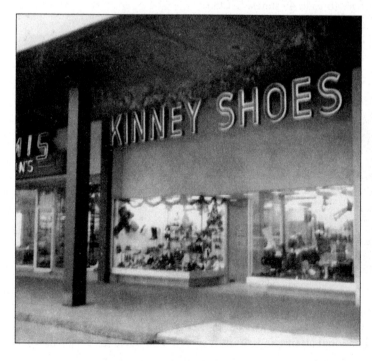

Kinney Shoes Northland store was the 325th in this national chain, considered the largest family shoe retail chain in the country beginning in the late 1930s. It specialized in shoes for the whole family, including athletic footwear and slippers. The first Kinney store opened in 1894 and its four shoe factories produced 15,000 pairs a day at the time. Kinney was among the first 30 stores to sign a lease in Northland. In the early 1960s, the company was sold to the F.W. Woolworth Co. (COS.)

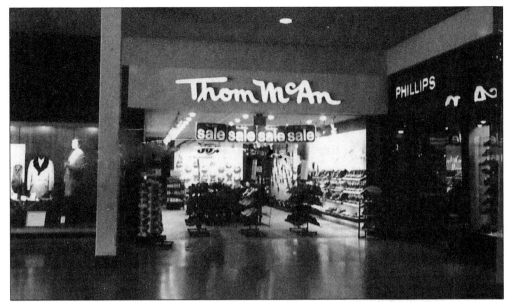

Thom McAn's 13th store in the Detroit area was located by the Fountain Court. When this charter tenant opened, it sold most of the company's 175 shoe styles for men and boys in a traditional store decor of gray and green. In 1965, Thom McAn combined with radio station WKNR Keener 13 to offer a contest prize: a new "GeeTO Tiger worth more than $3,500!" While Thom McAn had hundreds of retail stores at one time, the company is now part of Sears Holdings. (COS.)

Owner Rob Wolk opened Sundance Shoes Northland store in 1973. Initially a small 500-square-foot location, the store did so well it quickly moved to larger space. Located next to Hughes & Hatcher, Sundance, pictured here in the early 1980s, focused on great merchandise and service. Rob Wolk learned the business from his father, David, and today Katie Johnston, Rob's daughter, helps run the store with her father. In the 1980s, Sundance Shoes relocated to West Bloomfield, where success continues. (SPL.)

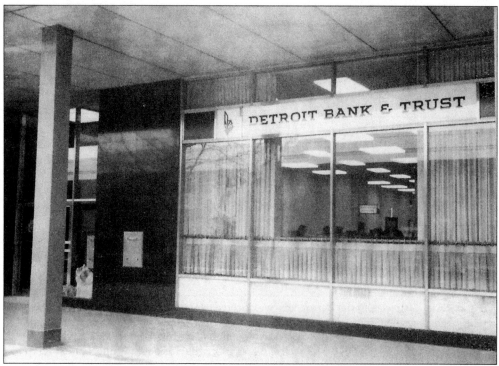

Detroit Bank & Trust had a main branch and an annex at Northland, including drive-through service. This photograph is from the early 1970s. The bank was formed with the consolidation of several banks in the early 1950s. Detroit Bank & Trust introduced its first automated teller machines and the Master Charge card in the early 1970s. (COS.)

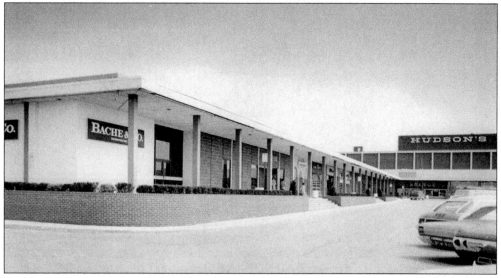

Bache & Company was a stock brokerage and securities investment firm. Founded in 1879 by Jules Bache, its would later be known as Bache Halsey Stuart Shields, then Prudential-Bache Securities when acquired in 1981. The Bache name went through additional changes after a series of business combinations in the investment banking industry. It was located at the end of the strip north of Kresge's and on the opposite end of the mall from J.C. Penney. (SPL.)

The Hudson's charge card was a treasured item—especially those from the 1950s with the green protective metal case. To many people, it was a first credit card, allowing them to say "charge it." Hudson's accepted it in every department within the downtown store and, with the new Hudson's Northland, it was welcome at both stores. There was no need to reapply, as this ad that ran just weeks before Northland's opening announces.

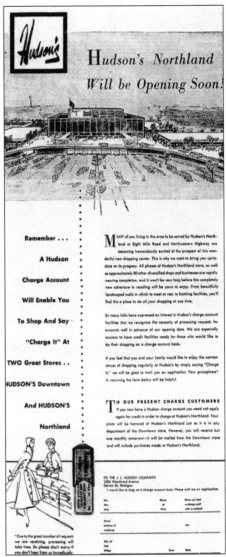

Hudson's Northland Will be Opening Soon!

Remember . . .

A Hudson

Charge Account

Will Enable You

To Shop And Say

"Charge It" At

TWO Great Stores . .

HUDSON'S Downtown

And HUDSON'S

Northland

Ross Music, located on the Terrace, opened as Center Music, one of the mall's first tenants. It was sold and renamed Ross Music by the second owner and sold again to Isadore "Irving" Schonberger and his longtime business partner, Sam Press. Ross Music grew to 11 locations, including Oak Park's Lincoln Center, selling records, cassettes, eight-track tapes, and accessories. Top 40 music guides from WKNR Keener 13, CKLW, and WCHB were available. (COS.)

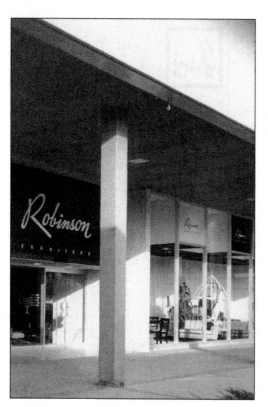

When it opened, Robinson Furniture became one of the largest of Northland's retail branches, with 42,000 square feet. The 160-foot window frontage and entrance featured white marble and black granite. A full range of furniture, draperies, carpeting, and more was offered by devising four levels of display within the two floors of the store utilizing mezzanines. This view looks northwest at the entrance from the Fountain Court. (Courtesy of Gruen Associates.)

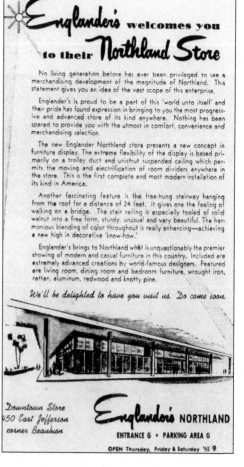

The Englander's Northland store presented an entirely new concept in furniture display, designed for completely flexible room and electrical systems to allow shifting displays, anywhere. The original Englander's store featured a stairway suspended by rods 20 to 30 feet long. The stairway, considered a conversation piece, was more than 16 feet high and was designed by Gruen Associates. It also included panels in turquoise, persimmon, and charcoal. (Courtesy of Gruen Associates.)

This original ad from 1954 encourages people to take advantage of shopping at the new Northland. It was convenient to reach by bus or major highways, with easy parking for 7,500 cars. There was something for everyone at the 80 retail stores. Northland had easy access, a variety of shopping choices, and the convenience of package pick-up.

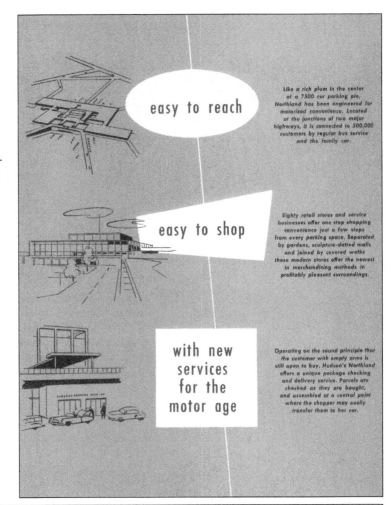

easy to reach

Like a rich plum in the center of a 7500 car parking pie, Northland has been engineered for motorized convenience. Located at the junctions of two major highways, it is connected to 500,000 customers by regular bus service and the family car.

easy to shop

Eighty retail stores and service businesses offer one stop shopping convenience just a few steps from every parking space. Separated by gardens, sculpture-dotted malls and joined by covered walks these modern stores offer the newest in merchandising methods in profitably pleasant surroundings.

with new services for the motor age

Operating on the sound principle that the customer with empty arms is still open to buy, Hudson's Northland offers a unique package checking and delivery service. Parcels are checked as they are bought, and assembled at a central point where the shopper may easily transfer them to her car.

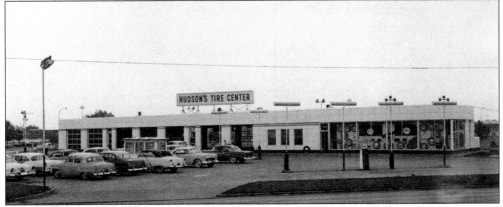

The Northland Tire Center was located on the southeast corner of the mall at Greenfield Road and Northland Drive. Tires and hubcaps are visible in the retail window display, and a serviceman and customer are visible at one of the bays. A variety of car makes and models are in the parking lot. The goal for Hudson's was to offer shoppers full service for their vehicles. (Photograph by Davis B. Hillmer, courtesy of Detroit Historical Society.)

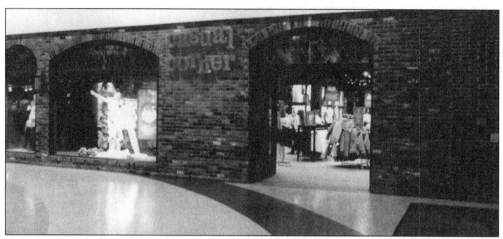

Casual Corner was located in the northeast corner of the center. This women's apparel chain was founded in 1950. It was sold to United States Shoe in 1970 when the chain had 20 stores, but expanded quickly in the 1980s (pictured) and 1990s, under the additional branded name of August Max Woman, reaching over 500 stores at its peak. After increasing competition, the stores and inventory were liquidated in 2005. (SPL.)

Crowley, Milner, known familiarly as Crowley's, was a department store chain founded in Detroit in 1909. It was liquidated in 1999. With stores in Detroit and elsewhere, it was a direct competitor to J.L. Hudson's but never had a store in Northland. This classy ad, indicative of the friendly competition between these stores, congratulates Hudson's and tenants on the opening and salutes the City of Detroit on forward-thinking plans for the civic center. (Courtesy of Bruce A. Kopytek.)

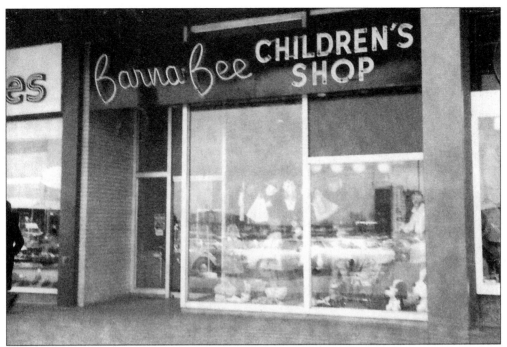

Barna-Bee Children's Shop, one of the original stores, was located near Cunningham's. In 1954, as Northland's only children's specialty shop, the children's retailer's slogan was "Shop at the Store with the Orange Door." Owners Leo Cohen and son-in-law Edward Resnick, with Ed's sons Michael and Jeffrey, "learned to survive as a small fish in a very large pond, Northland Shopping center" as the *Free Press* termed it in 1974 for the store's 20th anniversary. (COS.)

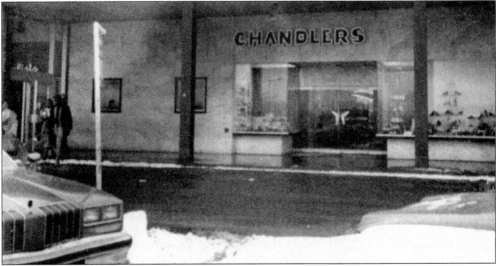

Chandlers shoes, another original tenant, was the chain's second location in the Detroit area, and the 50th in the nation. Chandlers, located off the Great Lakes Court, was the exclusive outlet for French Room Originals women shoes, which retailed from $9.98 to $12.95 at the time. Handbags, hosiery, and casual shoes were also available. The exterior was white marble, with the marble theme continuing inside in the display area and planter box, with hand-painted murals depicting Paris scenes above. (COS.)

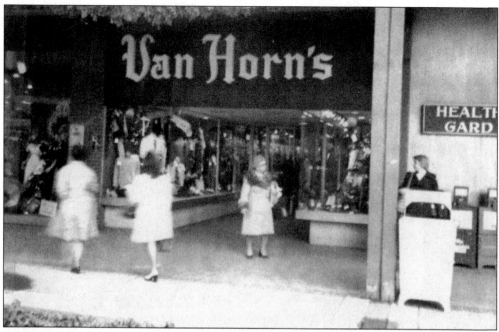

Van Horn's was founded by Neil Van Horn in 1947, with Northland being the third of his 11 Michigan stores. It was located in the East Mall and closer to Kroger's. The business sold men's suits, shirts, ties, sportswear, and accessories. It also had an exclusive on Manhattan dress shirts at the center. Competition and changing demographics of the market forced the company to file for bankruptcy in 1989. (COS.)

Morris Disner & Sons, located near the Great Lakes Court, was one of the original Northland tenants. Founded in 1906, it originally specialized in custom-made clothing and then added ready-to-wear men's clothing in 1944. Disner's utilized the additional floor space in Northland by adding hats, shoes, and a complete line of men's accessories. This 1954 ad ran prior to the move to Northland from Cass Avenue by the General Motors Building.

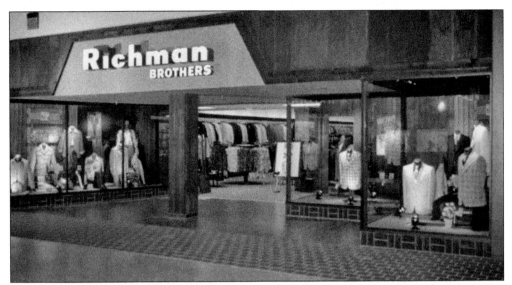

Richman Brothers, a men's clothing manufacturer and retailer, opened its Northland store in 1963. It was the company's eighth in the area, and there were over 250 nationally. Founded in 1853 by Jewish Bavarian immigrant Henry Richman Sr. and his brother-in-law Joseph Lehman, the first store was located in Cleveland, Ohio. The business became Richman Brothers in 1904 when Henry's three sons took over the company. Their $4 million men's and boy's clothing store in 1931 Detroit was the largest in the country. After merging in 1969 with F.W. Woolworth, Richman Brothers was liquidated in 1992. (Courtesy of Karla Bellafant.)

Himelhoch Brothers & Company was founded on the site of the Hudson's downtown store nearly 50 years before opening its Northland store. This was its third suburban branch, following Birmingham and Grosse Pointe. The company had a national reputation for high-fashion merchandise. Architect Victor Gruen designed the store's garden-style facade and interior pillar lights. The distinguished interior had ornamental lighting fixtures, including a brass sculpture by Malcolm Moran and a crystal fixture by Dorothy Greene. (COS.)

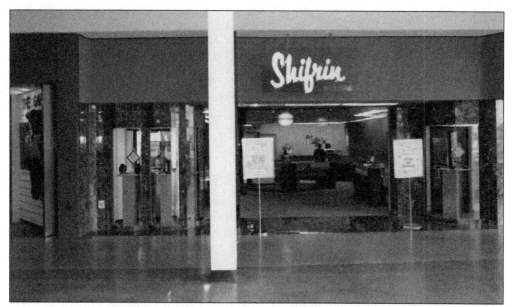

Owned by Nathan Shifrin in the 1940s on the west side, Shifrin-Willens Jewelers grew to become a prominent 25-store chain in the Midwest. Robert Willens and his brother Lionel opened Willens Jewelers on the east side. Two neighborhood retail jewelers were brought together in advertising and business, jointly sponsoring movies on WWJ-TV. During the 25th anniversary celebration in 1979, the business was known as Shifrin-Willens, which filed for bankruptcy in 1984 and was purchased by another company. (Courtesy of Karla Bellafant.)

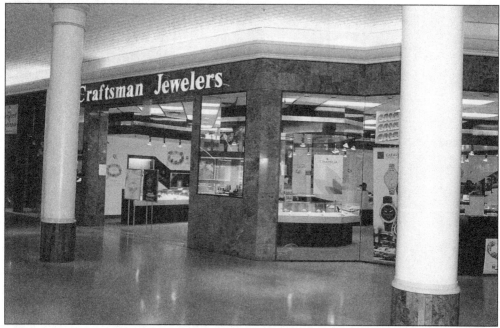

Craftsman Jewelers was one of the last remaining stores as Northland Mall closed in 2015. A comparison to the image on page 83 shows the design of the storefront is the same as the Meyer Treasure Chest store, as Craftsman took over that location. Peter Bedrossian, the owner, relocated about one mile north in Southfield in order to continue to serve the community. (Photograph by the author.)

Meyer Treasure Chest opened this, its eighth store, in September 1958. Carrying more than jewelry and watches, it was located along the east wall of Hudson's across from Raimi Curtains. The store's grand opening sale included Ronson lighters and shavers, General Electric alarm clocks, and Sunbeam appliances. Meyer acquired the 1865 Engass Jewelry Company in 1958. By 1959, Meyer announced it was doing the biggest volume of business of any individual jewelry firm in the state. (COS.)

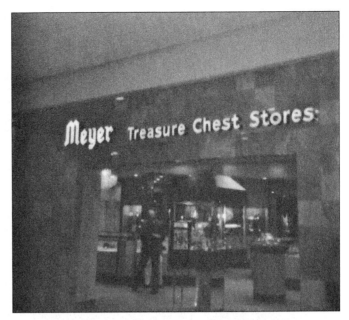

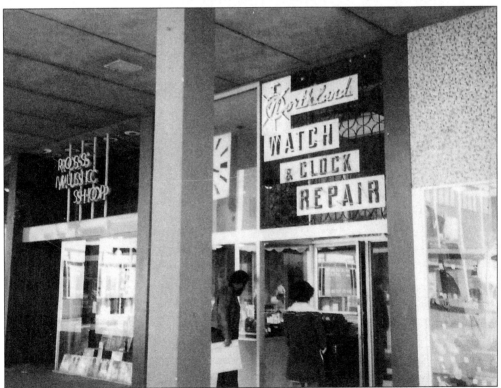

Northland Watch & Clock Repair Service was located off the terrace by the bus stop. It was sandwiched between Butler Shoes and Ross Music in the southwestern portion of the mall. The store was near Elias Brothers Big Boy and *The Boy and Bear* at the terrace. It was previously owned by Alfred A. Helfgott, who passed away in 1984. The business became Thie's Watch & Clock. (COS.)

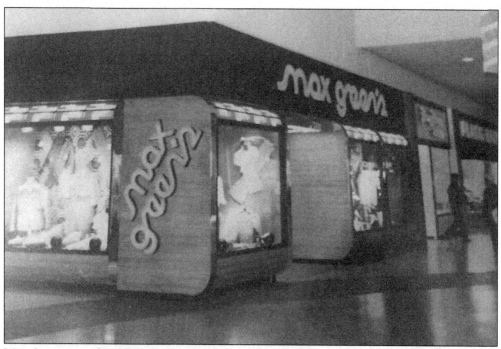

Max Green started out as the manager of Adam Hats on Woodward and West Grand Boulevard. When that store closed, Green purchased it and opened the first Max Green's Men's Wear in 1954. When Northland opened, Max Green's expanded and a store was opened in 1962 followed by a store in Eastland Mall in 1966. In 1972, the separate store Max's was opened in Northland. Max Green's was, in the 1990s, Northland's oldest men's clothing store. The stores specialized in men's suits and sportswear. (Both, courtesy of Max Green's children.)

Jack's Place, owned by Garry Kappy, his sister Leah Zuker, and his son Ira opened in 1966. It was located in the north mall near Max Green's and Todd's. Garry and Ira are pictured in front of the store. Jack's Place clothed many prominent political and sports figures in Detroit. Prior to the Northland store, Kappy owned regular and big-and-tall men's stores on Livernois Avenue, along the "Avenue of Fashion." The name "Jack's Place" was the name of the original store on Davison Avenue in Detroit that Kappy bought in 1955. In 1994, the Northland store was relocated to Lathrup Village, where it continued to provide quality service and merchandise to its clientele. (Both, courtesy of Dr. Irvin Kappy.)

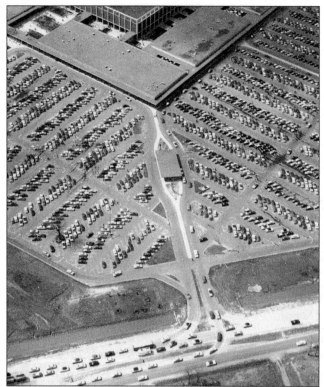

This early 1950s photograph gives a close-up view of the southeast part of the mall, with Greenfield Road running along the bottom. The small building at center, with the Kroger supermarket to the left, would be home to three distinct places—first, the Kroger package pick-up in the 1950s and 1960s; next, Puppy Palace; and finally, the Southfield Police Department. (Courtesy of Gruen Associates.)

The Kroger supermarket provided a unique service, consistent with Hudson's philosophy. Through a policy encouraging larger purchases at checkout, Kroger customers could have purchases sent to this outside pick-up point. Employees placed them on a conveyor that ran below ground, out of the building via a 90-foot tunnel to this specialized brick building between Kroger parking lots F and G. The driver pulled up, showed a number, and the packages were placed in the car. (Richard W. Frey Collection, courtesy of Tom Frey.)

Kroger's Conveyor Pickup System At Northland Center

You'd think it was a circus, from the mob of kids and grown-ups looking in the window to watch it. But it's just that very modern and convenient package pickup system at work, in the Kroger Supermarket at Northland Center.

From the check-out, those customers who wish to have their purchases sent to the outside pickup point, turn them over to the pickup boys who place them on this conveyor. The conveyor then runs below ground, out of the building and through a 90-foot tunnel to the specially built brick building out between the two Kroger parking lots (F and G).

Here It Comes!

Here comes the conveyor, up and out from the tunnel, into the pick-up building.

There It Goes!

The customer drives by, on either side of the pick-up building, shows her number and the package is placed in her car. Thus she is left free to do other shopping, or go after her car if parked at a distance without having to carry a heavy bag. All of which promotes larger

86

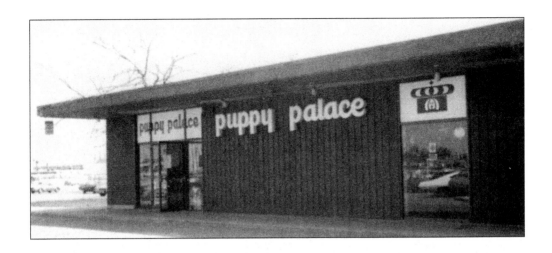

Puppy Palace was the second use for this building. The company said each puppy it sold was a purebred from reputable breeders and each had its puppy shots. Pet supplies and other dog items and toys were sold. One Facebook fan remembers buying his first Maltese pup here more than 30 years ago. The Southfield Police Department downtown station was the third use for the building. A plaque on the inside wall reads: "Dedicated March 7, 1991 to the Citizens and Visitors of the City of Southfield, Michigan. Southfield Downtown Development Authority." The officers of the department provided quick response to the mall and surrounding area, supplementing Northland's private security officers. The department sponsored many worthwhile community policing events for more than 20 years. Although it was closed as the mall shut down, a proposed development at the site may reopen the station. (Above, photograph COS; below, photograph by the author.)

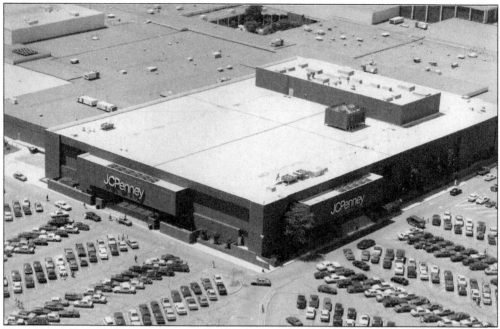

These are two views of J.C. Penney and neighbors after the enclosure in 1975. The Great Lakes Courtyard in the above photograph is the only open area. Dayton Hudson spent $25 million each at Northland and Eastland to enclose each center and add new J.C. Penney stores. Joe Hudson Jr., vice chairman, said then that "Northland is today another downtown. It does more volume today than the downtown area does." The expansion and enclosure was expected to boost sales at both centers by 25 percent in 1975. Evaluations of the downtown Hudson's store were continuing at the time, with reviews of declining population trends and sales volumes. The enclosure of the center was expected to improve attractiveness and security, while experts said it would not require additional energy costs. In 1974, J.C. Penney was the nation's fourth-largest retail chain, preceded by Sears, Montgomery Ward, and S.S. Kresge. Penney's auto center was located nearer Greenfield Road. (Both, courtesy of Karla Bellafant.)

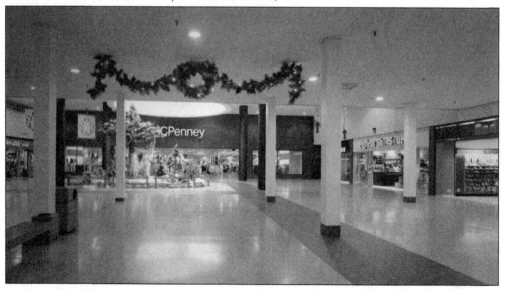

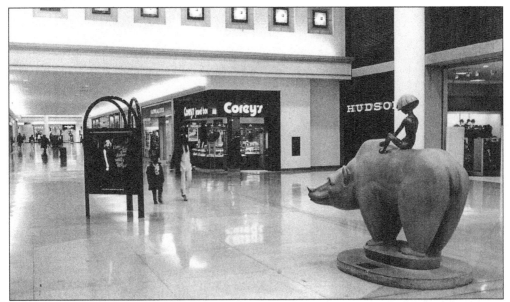

Harold Rubinstein and his wife, Charlotte, founded Corey's Fashions, a Detroit women's wear store, in 1949. That store's jewelry counter was so successful that the Rubinsteins closed Corey's Fashions, opening Corey's Jewel Box in Northland in 1954. By 1983, Corey's, a name borrowed from then movie actor Wendel Corey, had grown to 15 stores around metro Detroit, eventually expanding to 40 stores throughout the Midwest by the chain's 50th anniversary. Originally next to Big Boy, the store was relocated to this site with the mall enclosure. (NA.)

The bookend store was located on the eastern side of Hudson's, across from Father & Son shoes. Family-owned Marwil's, a competitor and an original store at the center, occupied less than 300 square feet in a glass-enclosed kiosk by the community concourse. Both stores offered the latest in reading material along with tickets to many events and shows. Marwil's also sold paper-covered and laminated-board books for readers of all ages, priced as low as 25¢. (SPL.)

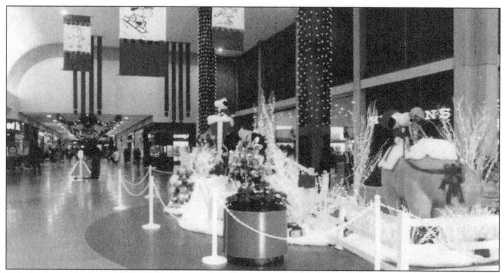

Hudson's always had elaborate interior and exterior displays for the holidays. In this 1980s photograph, Snoopy and the Charlie Brown characters are featured outside the northeast entryway to Hudson's. This view looks south toward Corey's Jewel Box in the distant right and United Shirt, the Wild Pair, and Father & Son to the left. Purists of *The Boy and Bear* may not appreciate the added decorations, including Snoopy riding the bear. (SPL.)

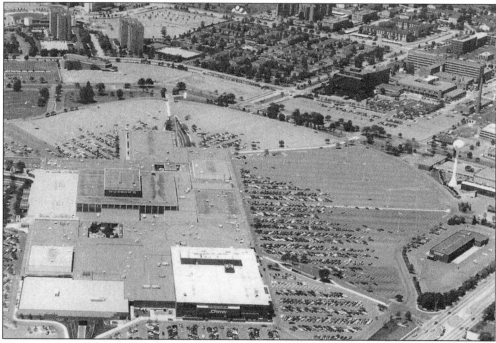

This aerial view from the 1980s looks northwest over the enclosed mall, with Kohl's to the front left and the tunnel entrance below. Northland Theatre is at upper left, the water tower and maintenance building are at lower right, and Providence Hospital is at upper right. The Northland Auto Center, fronting Greenfield Road on the right, later became the J.C. Penney Auto Center and Goodyear service. The small building to the right of J.C. Penney is discussed on pages 86 and 87. (SPL.)

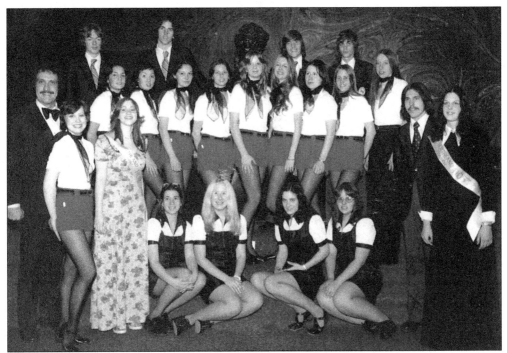

Northland Theatre, called "the incomparable showplace for fine motion pictures," was transformed into the theme of the current movie. Whether *Airport* in 1970—when the lobby was converted into the "Northland Airport Terminal" with Hertz and Avis rental desks—or *Fiddler on the Roof* or *Love Story*, guests were put in the mood as they entered. Eugene Grew was the only manager to twice win the National Association of Theatre Owners First Place Showmanship Award of Michigan, out of more than 60 theaters, and first place in the Quigley (New York) Showmanship Award. The group picture is from January 1, 1974. Employees were dedicated and professional. Some called the theater the "Fisher Theatre of the movie theatres," alluding to the classy operation. Below is the grand opening ad from August 17, 1966, with Alfred Hitchcock's *Torn Curtain*, the first film shown. (Both, author's collection.)

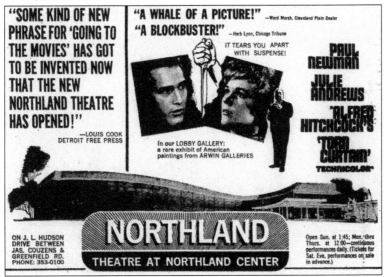

Workers construct the geodesic dome at Northland in 1957. Several cranes are used to hoist and place the structure. The domes date back to 1919, but it would be 30 years later when R. Buckminster Fuller invented a structure that could be mass-produced. He received a patent in 1954 and the structure gained popularity during the 1960s and 1970s. One structure was built at Walt Disney World's Epcot Center in 1982. Fuller built a dome in 1953 for the Ford Motor Company for its Detroit headquarters courtyard. The Defense Department was Fuller's largest customer. There were residential dome kits manufactured as well. The photograph below shows the opening of the Northland Playhouse in the geodesic dome. The original playhouse was a 1,500-seat tent that opened in June 1956. Strong winds would blow the tent away, cancelling the performance. The mosquitoes were troublesome as well. (Above, NA; below, courtesy of Ray White.)

This is the original 1966 playbill for what was Northland Playhouse's last season. Kenneth E. Schwartz, producer and general manager, brought in highly recognizable actors with top productions. Names include June Allyson, Yvette Mimieux, Cliff Arquette, Louis Nye, Mae West, Ethel Waters, Ginger Rogers, Eva and Zsa Zsa Gabor, William Bendix, George Jessel, and Red Buttons. A young James Coburn was a resident leading man the opening summer of 1958. Ironically, the final performance was *The Unsinkable Molly Brown*. (NA.)

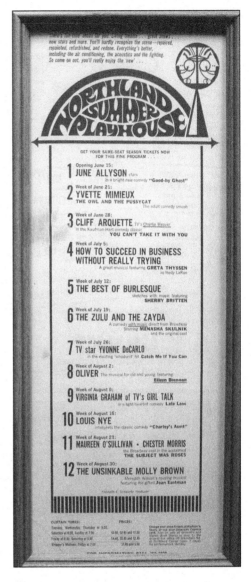

The 1959 summer season in Northland's Playhouse began with William Inge's drama *Picnic*, introducing Robert Horton as the vagabond Hal Carter. Horton starred in TV's *Wagon Train* series between 1957 and 1962. One of the busiest actors in Hollywood, he performed in television, movies, and on stage. A sellout for this grand opening of the fourth season, and first under the dome, caused it to be extended for 10 more performances. (Author's collection.)

These ads for the new teen club the Mummp illustrate the excitement and the interior during the grand opening on December 10, 1966. M.C. Robin Seymour of CKLW-TV introduced top local bands like Mitch Ryder and His Motor City MC 5, Stoney and Jagged Edge, Amboy Dukes, and the Shy Guys, whose song "We Gotta Go" hit the charts. Other performers at the Mummp included Gino Washington, Tidal Waves, and Band of Gold, for whom Mummp co-owner Hy Weinstein produced a 45 record on the Mummp label. The ads proclaimed the Mummp as "Michigan's largest, newest and most beautiful young nightspot". Go-go girls, nonalcoholic exotic drinks, and special pizza dogs were featured. Todd and Lee Weinstein controlled the psychedelic light show and the revolving stage, which alternated to allow for nonstop music including "greaser" and "hippie" bands. (Both, courtesy of Todd and Lee Weinstein.)

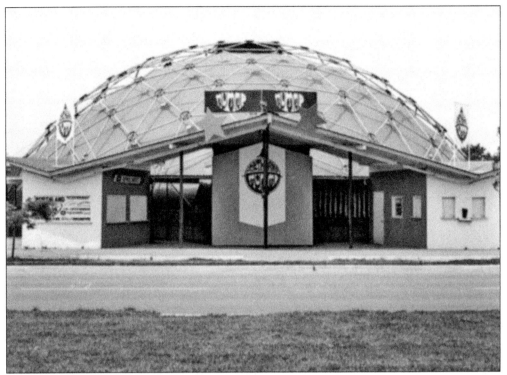

The Mummp opened December 10, 1966, in the old Northland Playhouse. It was operated by Hy Weinstein and Bernard Adelson, who renovated the geodesic dome with table seating, a dance area, and a new heating and cooling system. The club, catering to young adults, was open Thursday through Sunday evenings with admission charges of $1.50 for persons aged 16 to 21, with matinees for $1. Success led to the opening of a second club called ByPass, in Brighton. (Courtesy of Todd and Lee Weinstein.)

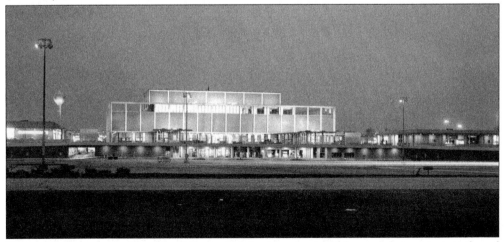

The sun sets on iconic Northland for one of the last times. With it set the memories of good times and bad. There will probably never be anything to equal Northland again. The history, the grounds, the activities, the sculptures, the businesses, the people—Northland was one of a kind for 61 years. Whatever Northland represents to the reader, may it include pleasant memories. (Courtesy of Gruen Associates.)

Visit us at
arcadiapublishing.com

CPSIA information can be obtained
at www.ICGtesting.com
Printed in the USA
LVOW02*1213150517
534568LV00003B/23/P

9 781531 699734